Acknowledgments

En Route required the talent and support of many people including Erlyn, Les, Frank, Ja... ..., Jack, and King Monty.

The design talents of Brian Lane, Henry Vizcarra, and the staff of 30Sixty Design are evident. Photographic assistance was offered by Scott Hensel and Scott Bloom, while D.J. Nellis was responsible for inputing the copy.

In compiling the labels for *En Route*, the assistance of Hal Turin was invaluable. A dealer in collectibles, Hal has one of the world's largest collections of airline labels. He can be reached at P.O. Box 663, San Dimas, California, 91733.

Special thanks to Shelly Hurst, Sandra Forney, and Anne Arrowsmith.

Copyright © 1993 by Michael O'Leary. All rights reserved. No part of this book may be reproduced in any form without written permission from the publisher.

Library of Congress Cataloging in Publication Data available

Printed in Hong Kong.
ISBN 0-8118-0045-8

Distributed in Canada by Raincoast Books, 112 East Third Ave., Vancouver, B.C. V5T 1C8

10 9 8 7 6 5 4 3 2

Chronicle Books
275 Fifth Street
San Francisco, CA 94103

Contents

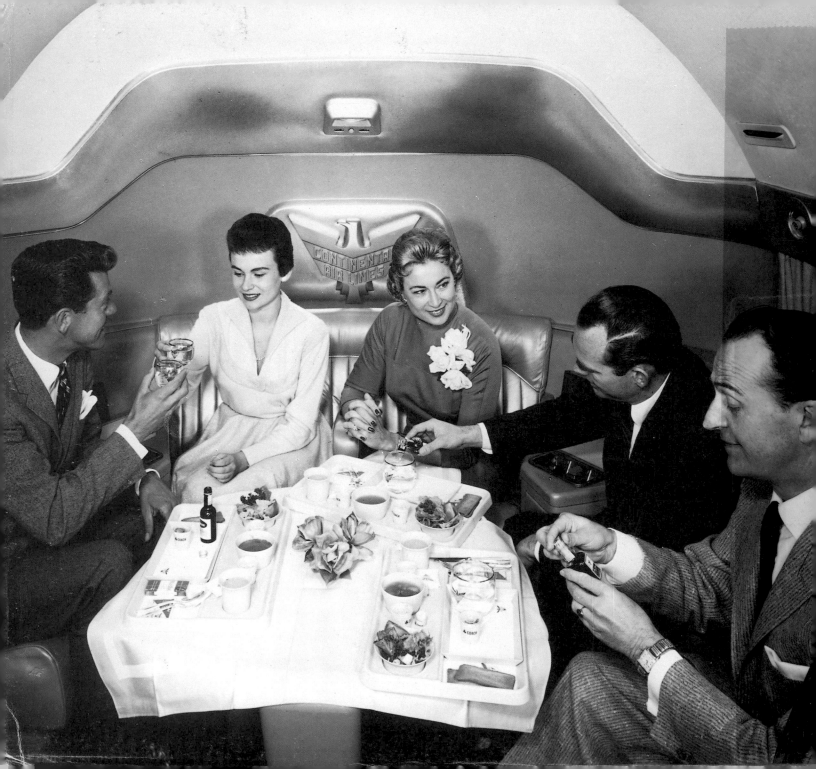

ON FOSTER CITY & COUNTY PUBLIC LIBRARY

EN ROUTE

LABEL ART FROM THE GOLDEN AGE OF AIR TRAVEL

EN ROUTE

LABEL ART FROM THE GOLDEN AGE OF AIR TRAVEL

BY
LYNN JOHNSON & MICHAEL O'LEARY

CHRONICLE BOOKS · SAN FRANCISCO

Introduction

Few endeavors in mankind's history have had more impact in such a short time than aviation. In the space of a single lifetime, man went from the first tentative flights at Kitty Hawk to landing on the moon. Accordingly, the development of air transport rapidly broadened mankind's horizons and opened areas of the globe that were previously inaccessible.

Early air travel was an adventuresome affair—for leisure passenger and businessman alike. Aircraft were primitive, reliability was negligible, and routes few. However, for those willing to take a risk, travel could be achieved in a much shorter time span than by the more common transportation methods of the day—ship or rail.

As the technology of aviation matured, reliability of aircraft and aero engines greatly increased the number of passenger miles being flown. Competition for the passenger dollar became intense and the most notable advertising method used by individual airlines was the issuing of luggage labels—the

subject of this book. The distinctive labels marked the traveler as a person of substance (air travel was not inexpensive) and adventure.

In *En Route*, we have elected to examine labels issued at the dawn of passenger flight through the advent of the jet airliner—at which time much of the glamour associated with air travel waned. The labels are representative of each design period commercial aviation passed through—including Edwardian and Art Deco. The stylized shapes of the aircraft of the 1930s were particularly well-suited to the concepts of Deco and Modernism.

As well as conveying changing design concepts, the following labels also show the shifting nature of history. Some countries mentioned in *En Route* have completely disappeared due to war or changing political sensibilities. The collection featured in this book attempts to capture an exciting moment in history when adventure, technology, and art were fused into one decorative form.

UNITED AIR LINES
UNITED STATES
CIRCA 1939

UNITED'S CLASSIC SHIELD INSIGNIA LABEL WAS
PRESENTED TO TRAVELERS IN A CELLOPHANE BAG.

LYNN JOHNSON MICHAEL O'LEARY
LOS ANGELES, JULY 1992

LABELS FOR YOUR
Luggage
UNITED
AIR LINES
PERMANENT ADDRESS OF MAINLINER PASSENGER
NAME
ADDRESS
CITY & STATE
Printed in U.S.A.

The Fledgling Takes Wing

Labels from the world's early airlines

The conclusion in 1918 of the Great War saw the battlefield use of the aircraft as an everyday event as an important factor in the final Allied victory. Although military aircraft orders rapidly dried up after the war, a few visionary capitalists saw a day when travel by aircraft would be commonplace. A stumbling block of major proportion was the fact that such a piece of equipment as an "airliner" did not exist. The builders of now-unnecessary combat planes were hungry for orders and were willing to listen to just about any proposal from this new field of entrepreneurs.

The most immediate solution to creating an aircraft that could somewhat reliably haul passengers was to take an already existing design and suitably modify the plane for its new role. Accordingly, war surplus de Havillands and Vickers were rebuilt to incorporate cabins that would handle small numbers of passengers. In Britain and France, a few airlines came into existence during 1919 and 1920 and began flying routes between various British cities and the Continent. The converted warplanes were sometimes not the

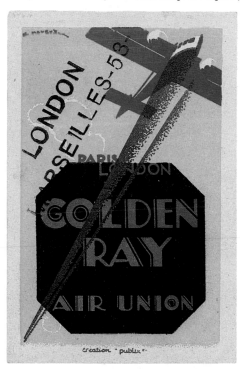

AIR UNION
FRANCE
CIRCA 1927
1

most reliable, but preliminary routes were forged between major cities like London and Paris as the passenger planes rumbled over the Channel. Larger twin-engine planes such as the Vickers Vimy often had cabins similar to an opulent Edwardian train car, albeit with roaring aero engines just a few feet from the ears of clientele.

Passengers flying these early services (there were no schedules as such, since maintenance and weather created havoc with published schedules) were a hardy bunch—either businessmen in a hurry or adventurers demanding a thrill. Services were not particularly cheap, and the airlines were quick to come up with an added incentive—baggage labels that advertised the airline while adding a certain dash of distinction to any passenger's luggage. Class-conscious travelers quickly took to the airline labels because they were indicative of a way of travel far removed from the extremely popular ocean liners and luxury trains of the time. Style was important, and one only has to view a label such as Air Union's "Golden Ray" Paris-London service to feel a sense of futurism and speed—even

though the mode of conveyance was, in actuality, a lumbering Farman biplane with a top speed of about ninety miles per hour.

The island continent of Australia took to air travel in a big way because the country's immense distances made other modes of travel a daunting venture. Several air carriers started up after the war, and a variety of bold and colorful labels came from the various services. Air travel took a quick and early hold in Australia and would never look back.

The world's new airlines went in and out of business with an almost depressing regularity, but a certain continuity did develop and established air carriers began to take root and prosper. Many airlines began to crop up in North America since, as in Australia, a quick form of transport was needed to traverse vast distances. The early airlines went out for passengers, and some truly stunning label designs resulted, many with a heavy Art Deco influence. Along with passengers, the airlines sought out lucrative government contracts for the new "air mail" and these contracts often spelled the difference between red and black ink. As need increased, so did the demand for new and more efficient aircraft. As the labels in this chapter illustrate, the fledgling airlines went from primitive biplanes to more efficient monoplanes in the span of just a decade.

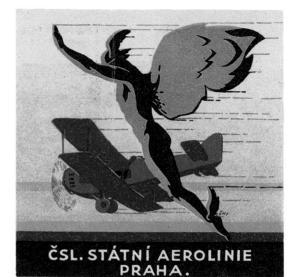

CESKOSLOVENSKE STATNI
AEROLINIE, CZECHOSLOVAKIA
CIRCA 1929
2

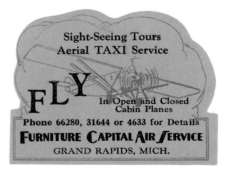

FURNITURE CAPITAL AIR SERVICE
UNITED STATES
CIRCA 1930
3

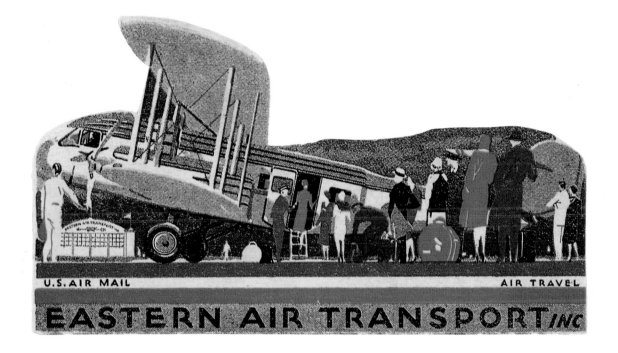

U.S. AIR MAIL AIR TRAVEL

EASTERN AIR TRANSPORT INC.

EASTERN AIR TRANSPORT, INC.
UNITED STATES
CIRCA 1930
4

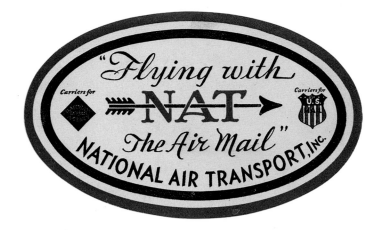

NATIONAL AIR TRANSPORT, INC.
UNITED STATES
CIRCA 1928
5

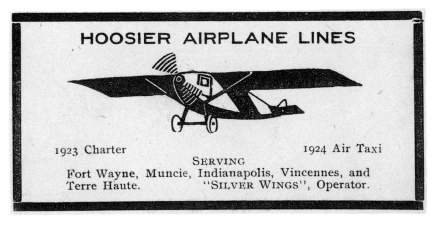

HOOSIER AIRPLANE LINES
UNITED STATES
CIRCA 1924
6

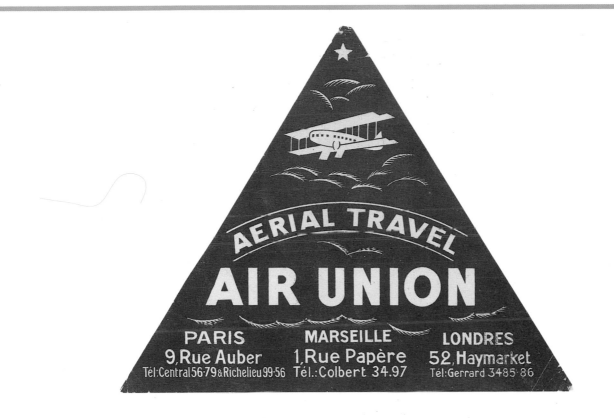

AIR UNION
FRANCE
CIRCA 1925
7

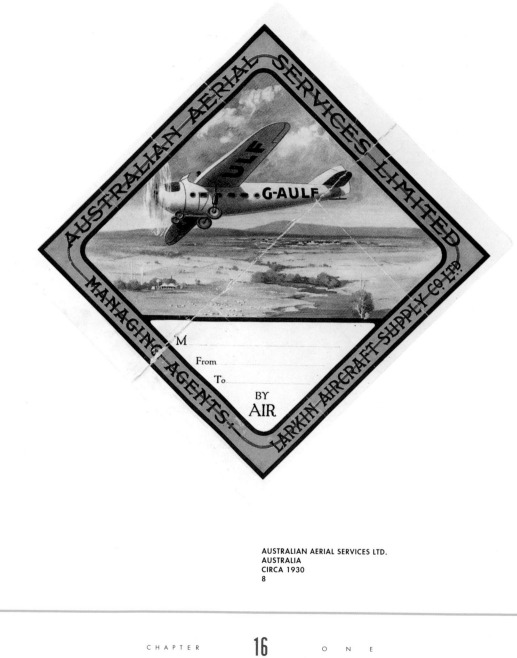

AUSTRALIAN AERIAL SERVICES LTD.
AUSTRALIA
CIRCA 1930
8

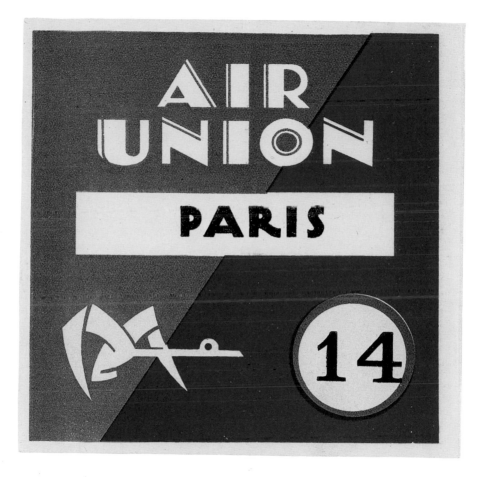

AIR UNION
FRANCE
CIRCA 1929
9

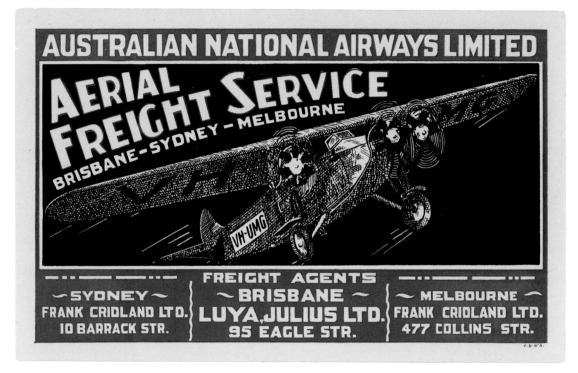

AUSTRALIAN NATIONAL AIRWAYS LTD.
AUSTRALIA
CIRCA 1930
10

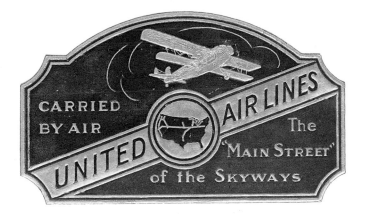

UNITED AIR LINES
UNITED STATES
CIRCA 1929
11

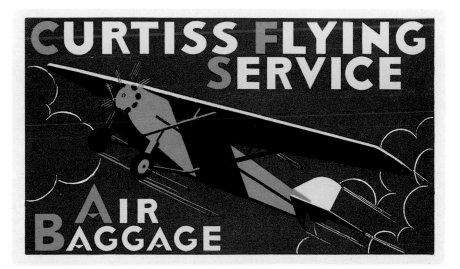

CURTISS FLYING SERVICE
UNITED STATES
CIRCA 1927
12

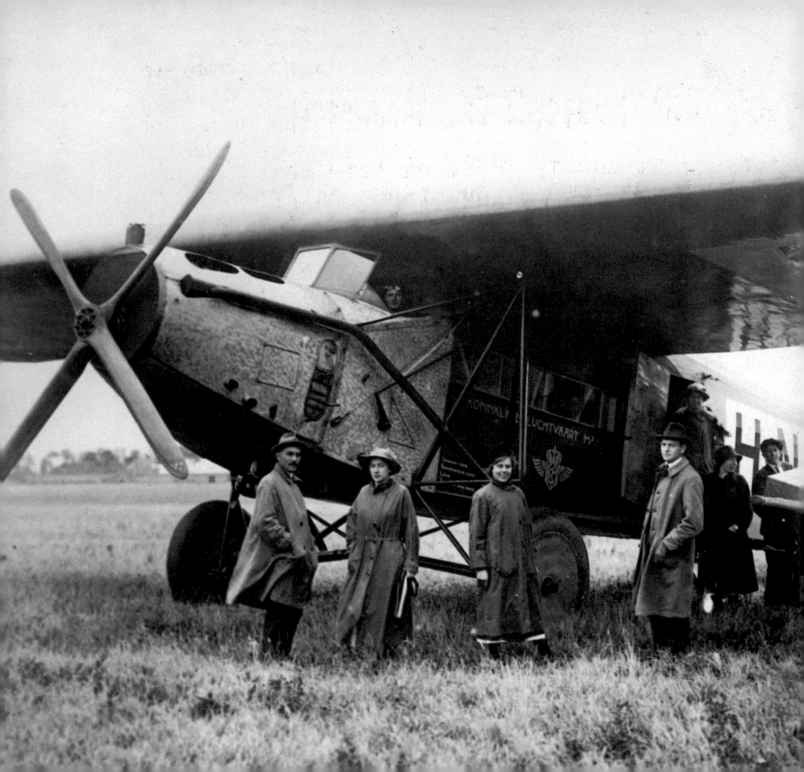

Labels from the airlines of Britain and Europe during the 1920s through the 1950s

As the decade that became known as the Roaring Twenties progressed, airlines and airline services began to proliferate throughout Britain and Europe. As a matter of national pride, many countries formed their own "nationalized" carriers that were funded either in part or whole by the particular government. However, there was also a fair amount of room for free enterprise, and a bewildering variety of carriers—for the most part short-lived—sprang into existence. Some of these carriers had but one aircraft, a pilot, and a mechanic—all of which had probably served in the Great War. The regulation of aircraft and airlines was still a few years off, and these "pioneering" days were rough-and-tumble with only the toughest surviving.

At that time, virtually every country had its own aviation manufacturing industry, and a variety of planes was constructed that included landplanes and seaplanes of all sizes and shapes. Seaplanes were extremely popular since many cities had harbors or rivers on which the craft could operate. Actual airports were rather primitive affairs—often merely fields that had

been marginally smoothed down, with a wooden structure serving as a terminal. Operators of seaplanes usually made arrangements with luxury hotels, where for a fee arriving passengers could be whisked away to the hotel with a minimum of discomfort. The image of the seaplane was particularly popular with Art Deco designers, and the image of these craft is frequently seen on labels of the 1920s and 1930s, with Italy's SISA being a particularly attractive example.

Since there were so many new airlines, labels proliferated as the carriers fought for every form of advertising possible. One of the most rapidly developing airlines was, oddly, Germany's Luft Hansa (the airline would not adopt its one-word name until after World War II). At the end of the Great War, Germany was prohibited from having any form of air force, but, because of the wording in the surrender document, the creation of an airline was not prohibited. With typical Teutonic efficiency, the Germans went about creating an airline that would quickly expand to a global network. Luft Hansa labels were numerous and, in a Germanic sense,

K.L.M. AIR LINES
THE NETHERLANDS
CIRCA 1919
1

quite colorful. One of the more interesting is the label that combines a vintage stage-coach being overflown by a Luft Hansa Junkers Ju-52 tri-motor airliner (complete with swastika).

Labels from pre-World War II airlines often incorporate national colors in the design, and many of these concepts are very creative, as illustrated by Czechoslovakia's CSL Statni Aerolinie and Poland's LOT.

The main pre-war airports of Europe and Britain were often quite imposing sights, with a wide variety of aircraft delivering passengers or cargo. As was the custom of the time, a national flag was flown from the cockpit when the plane was parked.

With the advent of World War II in September 1939, many national airlines disappeared overnight as the German blitzkrieg rolled across Europe, but some surviving aircraft managed to find safety in Britain or Switzerland. Britain's airlines basically became part of the military, even though they continued to operate limited civilian service. For the next few dark years, the subject of colorful labels was all but forgotten.

MAGYAR LEGIFORGALMI
HUNGARY
CIRCA 1925
2

ÖSTERREICHISCHE LUFTVERKEHRS A.G.
AUSTRIA
CIRCA 1925
3

A.B. AEROTRANSPORT
SWEDEN
CIRCA 1929
4

DEUTSCHE LUFTHANSA
GERMANY
CIRCA 1937
5

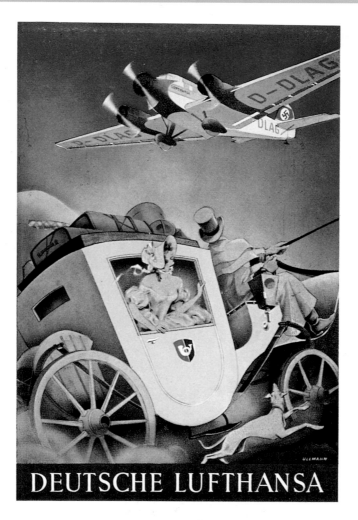

DEUTSCHE LUFTHANSA
GERMANY
CIRCA 1936
6

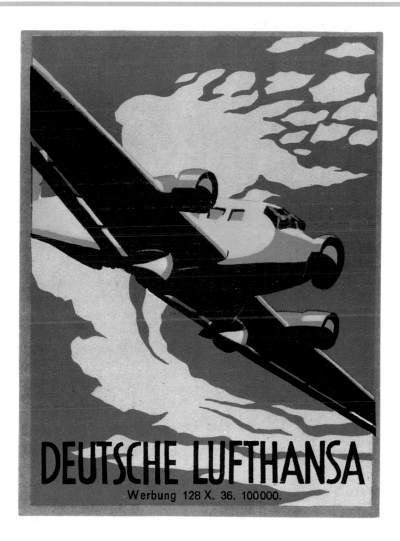

DEUTSCHE LUFTHANSA
GERMANY
CIRCA 1937
7

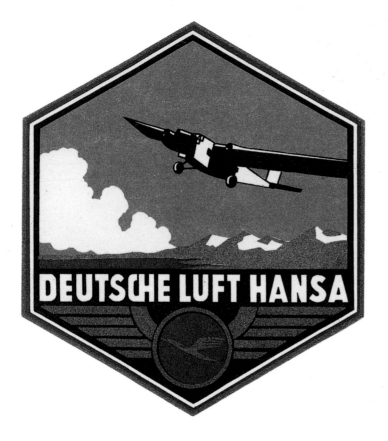

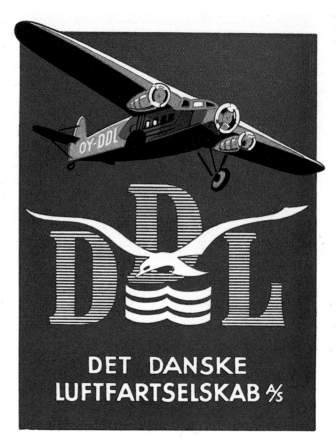

DEUTSCHE LUFT HANSA
GERMANY
CIRCA 1936
8

DET DANSKE LUFTFARTSELSKAB
DENMARK
CIRCA 1932
9

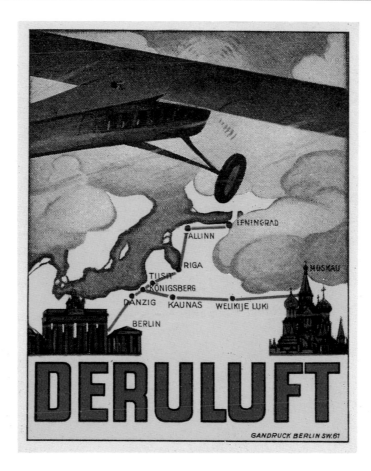

DERULUFT
GERMANY / SOVIET UNION
CIRCA 1928
10

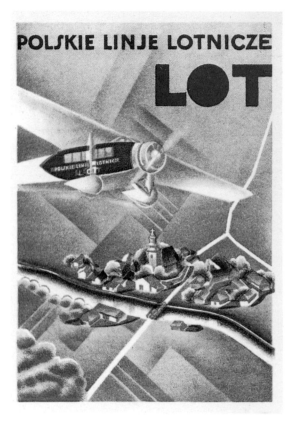

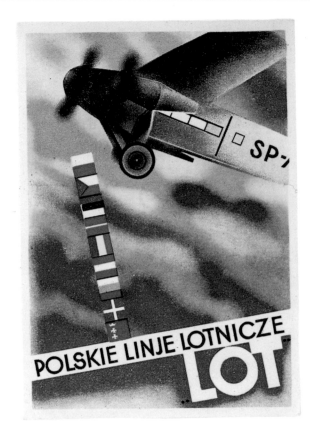

POLSKIE LINJE LOTNICZE
POLAND
CIRCA 1932
11

POLSKIE LINJE LOTNICZE
POLAND
CIRCA 1933
12

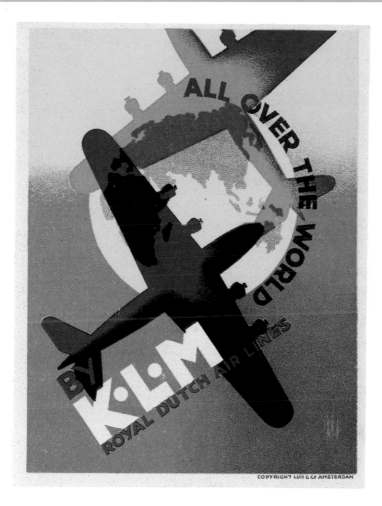

K.L.M. ROYAL DUTCH AIR LINES
THE NETHERLANDS
CIRCA 1950
13

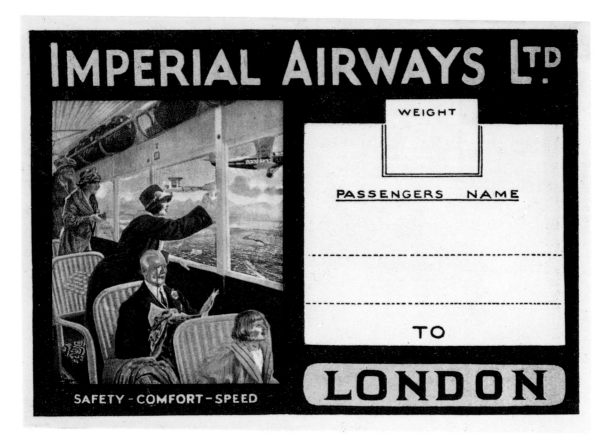

IMPERIAL AIRWAYS LTD.
GREAT BRITAIN
CIRCA 1924
14

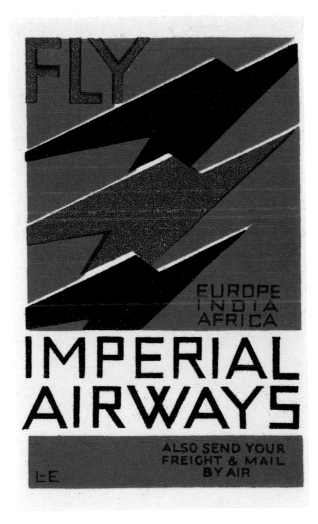

IMPERIAL AIRWAYS
GREAT BRITAIN
CIRCA 1938
15

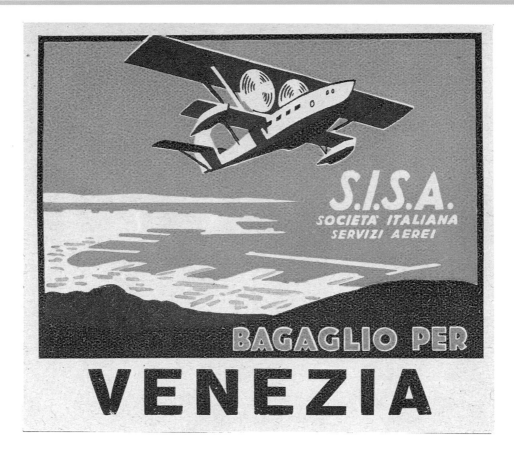

SOCIETA ITALIANA SERVIZI AEREI
ITALY
CIRCA 1926
16

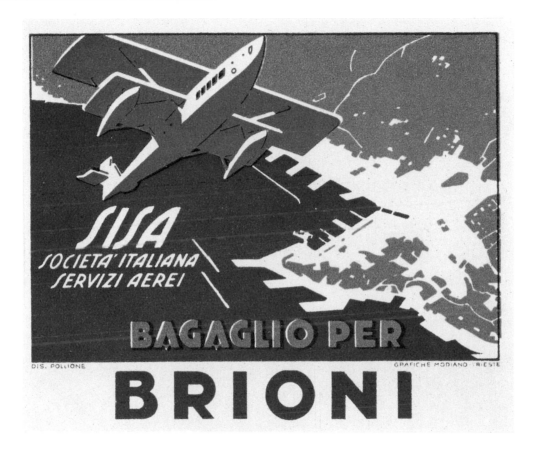

SOCIETA ITALIANA SERVIZI AEREI
ITALY
CIRCA 1929
17

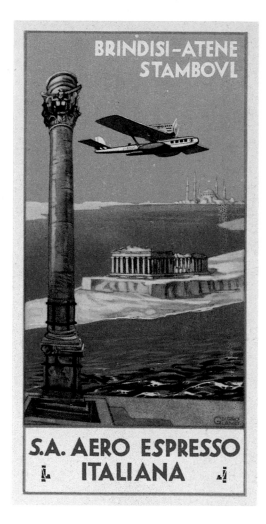

S.A. AERO ESPRESSO ITALIANA
ITALY
CIRCA 1927
18

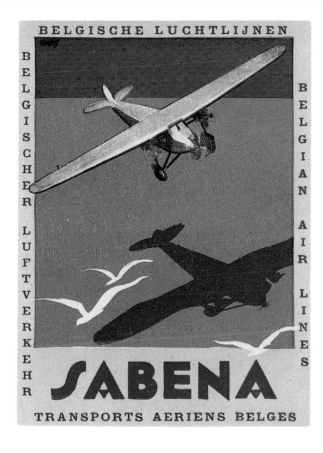

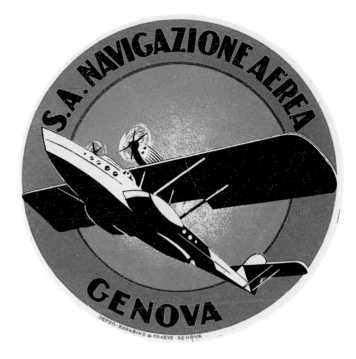

SABENA
BELGIUM
CIRCA 1932
19

S.A. NAVIGAZIONE AEREA
ITALY
CIRCA 1928
20

Labels that utilize stylized wings in their designs

Since the beginning of recorded history, man has been fascinated with the concept of flight. One aspect of this fascination can be seen in images of Greek, Roman, and Egyptian deities that had basically human form but were also fitted with varying degrees of wings. Throughout the years, the imagination of humanity fixated on being able to fly. The technical means were not available, however, until the invention of the Montgolfier brothers' hot-air balloon in France during the late 1700s and, of course, the Wright brothers' heavier-than-air Flyer in 1903.

With the advent of powered flight, wings became a common fixture in the logos of newly emerging aircraft manufacturers. Today, examples of these early logos (in the form of nameplates, stationery, etc.) are quite collectible. It was only logical that the early airlines would also adopt some form of wings to use on logos or as insignia on aircraft. Virtually every country had an airline that used such a design, and, as can be seen in this chapter, the label images varied from stylized wings to birds to symbolize flight.

Winged labels ranged from straightforward depictions to some rather fanciful portrayals. Canadian Airways Ltd. used a simple but effective design of concentric circles superimposed with the image of a Canadian goose in flight.

The use of birds was not limited to realistic portrayals, as can be seen by the ornate mythical creature portrayed on the label of Pacific Overseas Airlines (Siam) Ltd. The designer of this label was inspired by an old Siamese legend and used the winged creature as the company's corporate logo. Imperial Airways eventually became part of today's British Airways, but Imperial's stylized Art Deco logo of a "speed bird" is still used in a fashion modified enough to render the classic late 1920s design almost unrecognizable.

In the United States, many airlines made use of wings, and one of the most attractive uses is Continental Airlines' Indian chief in headdress, with a flowing stylized wing on the right side of the

EASTERN AIR LINES
UNITED STATES
CIRCA 1950
1

label and a streamlined aircraft on the left. Some wings on labels almost replicated the wings worn by pilots on their uniforms. Examples of this include the simple but attractive Alaska Star Airlines label, which would not look out of place on a pilot's jacket, and the wings on the label of the short-lived Veterans Air Line. After World War II, many ex-service pilots without jobs pooled money to purchase surplus transports—which were usually cargo carriers—and set up their own airlines. Veterans was such an airline, using a stylized V and wings for a logo. Most of these brave experiments were, unfortunately, regulated out of existence by the government under pressure from more-established carriers.

Oddly, today's airlines make very little use of any form of winged design—perhaps considering the style too dated or too far removed from passenger appeal. The labels in this chapter, however, show a time when the concept of flight still had a magic appeal to companies and passengers alike.

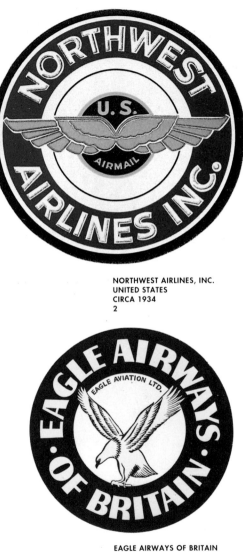

NORTHWEST AIRLINES, INC.
UNITED STATES
CIRCA 1934
2

EAGLE AIRWAYS OF BRITAIN
GREAT BRITAIN
CIRCA 1953
3

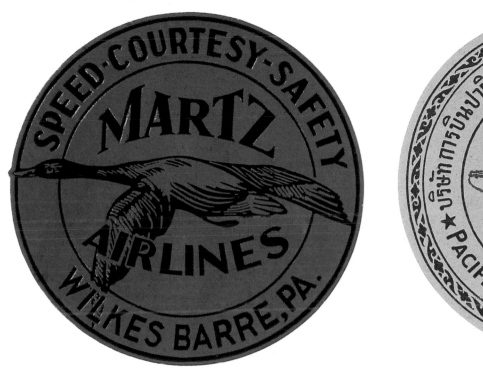

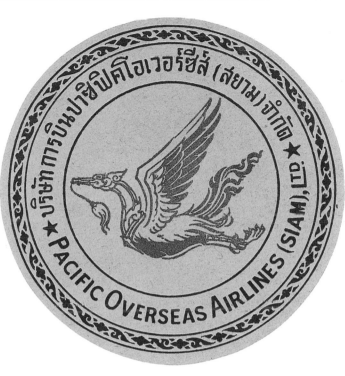

MARTZ AIRLINES
UNITED STATES
CIRCA 1930
4

PACIFIC OVERSEAS AIRLINES (SIAM), LTD.
SIAM (THAILAND)
CIRCA 1947
5

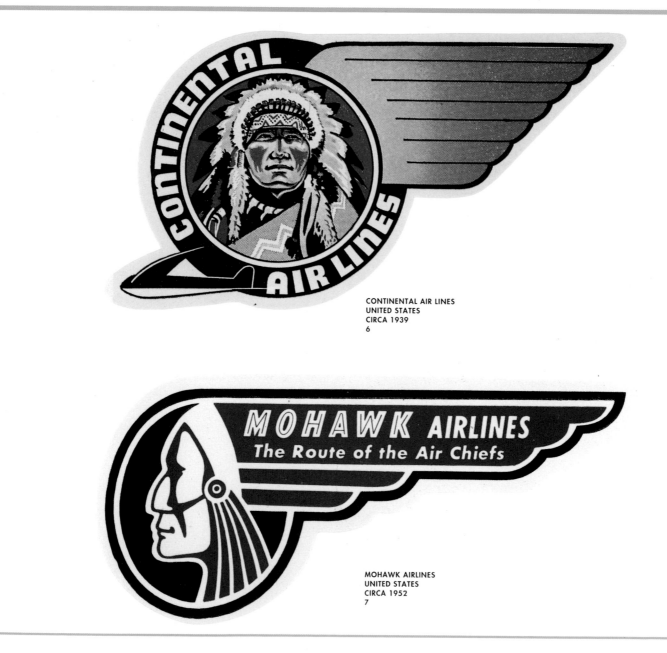

CONTINENTAL AIR LINES
UNITED STATES
CIRCA 1939
6

MOHAWK AIRLINES
UNITED STATES
CIRCA 1952
7

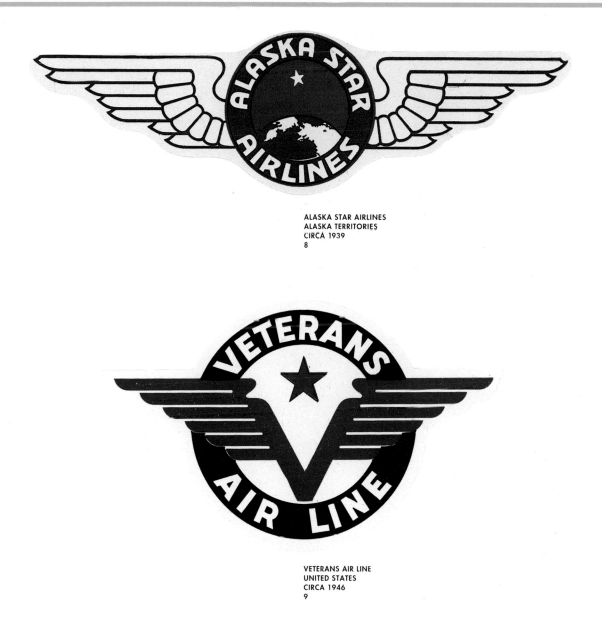

ALASKA STAR AIRLINES
ALASKA TERRITORIES
CIRCA 1939
8

VETERANS AIR LINE
UNITED STATES
CIRCA 1946
9

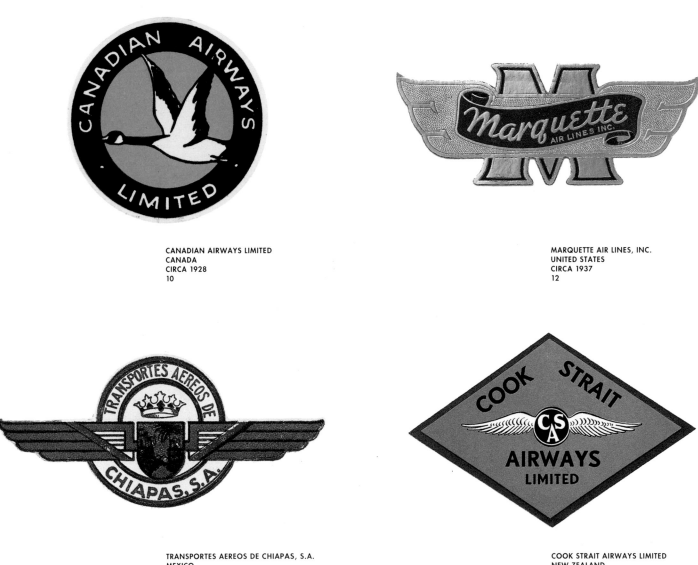

CANADIAN AIRWAYS LIMITED
CANADA
CIRCA 1928
10

MARQUETTE AIR LINES, INC.
UNITED STATES
CIRCA 1937
12

TRANSPORTES AEREOS DE CHIAPAS, S.A.
MEXICO
CIRCA 1937
11

COOK STRAIT AIRWAYS LIMITED
NEW ZEALAND
CIRCA 1936
13

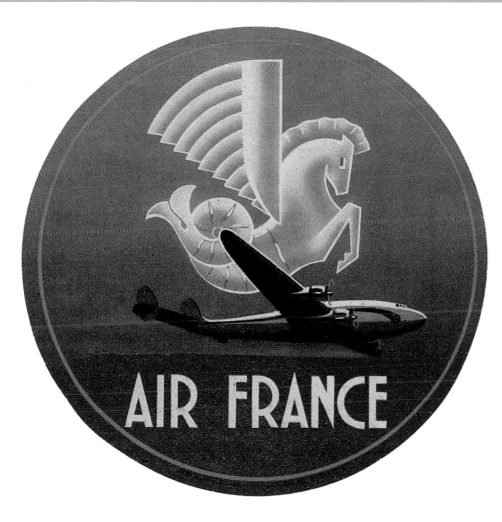

AIR FRANCE
FRANCE
CIRCA 1952
14

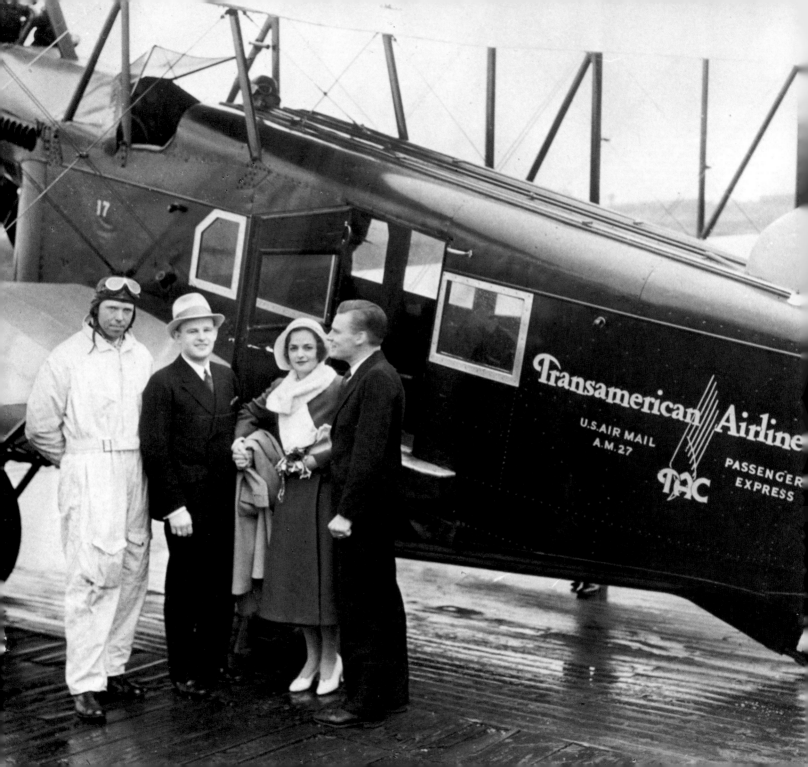

Cross-Country

Labels from the airlines of North America

By the start of this century, a fairly efficient rail system had been established that served the major cities of North America on a regular schedule. Rail travel was extremely popular when crossing the vast distances of the United States and Canada, and certain rail lines had prestige trains that appealed to the upper classes of the traveling public. Train travel did take a great deal of time and effort on the cross-country routes, however, and a few days of clanking over the rails could strain even hardy travelers.

The regular traveling public was greatly interested in the airlines' first attempts at coast-to-coast service, even though the early services were haphazard at best. It often took up to a mind-numbing two dozen stops to get from the Atlantic to the Pacific. Weather was also a huge factor, since the early aircraft had no capability of flying over the weather and would usually have to wait it out on the ground—throwing any sort of connecting schedules to the wind.

One way of establishing a viable cross-country route was to establish a network of smaller airlines that operated regular schedules among the larger cities across the continent.

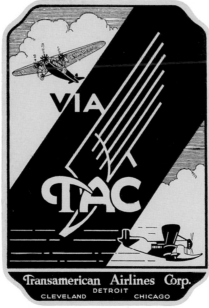

With this system, a traveler could work out a fairly practical schedule that could get him across vast distances faster than a train. Another method of cross-country operation was to have one airline establish a regular run that would either keep the number of transfers required to an absolute minimum or, ideally, keep the same passenger with the same plane for the whole flight.

One of the first lines that established a successful operation flying to a few major cities was Transamerican Airlines Corp., which operated from Detroit to Cleveland and Chicago. TAC's label on this page illustrates a winged logo flanked by a Fokker tri-motor and a Loening Air Yacht amphibian, the two types of aircraft used by the airline. Interstate Airlines, on page 53, offers a bold label in the form of the letter *I* and features an early biplane with a classic image of the fleet-footed Mercury giving service between Chicago and Atlanta. The Ludington Line label on page 53 offers Art Deco at its best, with a strong statement of geometric form and color. Ludington operated an East Coast service, flying Stinson tri-motors, and made the rather optimistic promise of service "Every Hour on the Hour." This type

TRANSAMERICAN AIRLINES CORP.
UNITED STATES
CIRCA 1930
1

of service eventually metamorphosed into today's popular "shuttles."

The simple but elegant Colonial Air Transport label shows a speeding Art Deco monoplane superimposed over a constellation. Colonial was a joint effort by a group of businessmen, including William Rockefeller, and originally operated the New York-to-Boston mail run before expanding to passenger service in 1927.

Air transport service was very important in developing the vast stretches of Canada, and many airlines and air services filled this need—including the famous "bush" airlines that went into remote areas with float- or ski-equipped aircraft. The metallic foil label issued by Wings Ltd. portrayed an exciting head-on view of a float plane ready for takeoff, while the whirling propeller disc drew attention to the company's "Expert Air Transportation." MacKenzie Air Service's appealing label depicts a twin-engine aircraft on skis flying over the top of the globe. Laurentian Air Services Ltd. chose an image of one of their Waco biplanes on floats flying over an idyllic setting. The majority of Canadian labels seems to incorporate as many natural elements as aircraft into the designs.

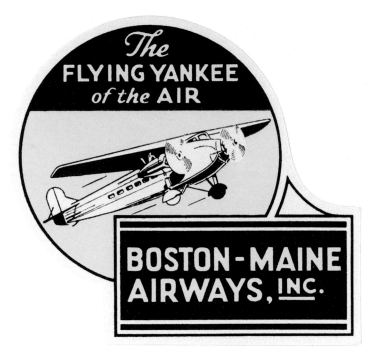

BOSTON-MAINE AIRWAYS, INC.
UNITED STATES
CIRCA 1931
2

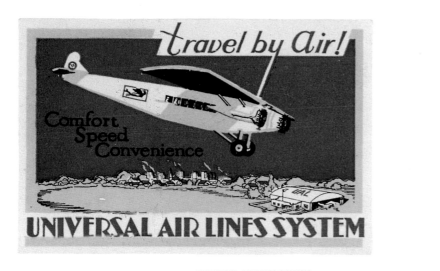

UNIVERSAL AIR LINES SYSTEMS
UNITED STATES
CIRCA 1929
3

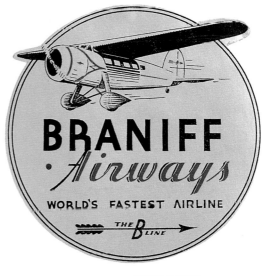

BRANIFF AIRWAYS
UNITED STATES
CIRCA 1930
4

CENTRAL AIRLINES
UNITED STATES
CIRCA 1934
5

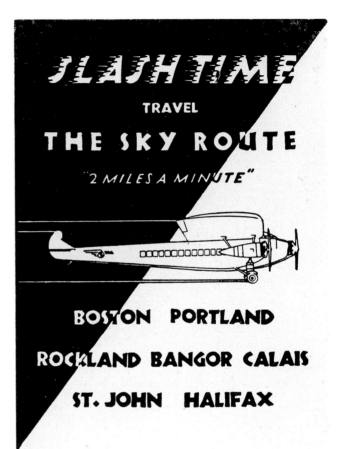

NEW YORK AIRWAYS INC.
UNITED STATES
CIRCA 1927
6

PAN AMERICAN AIRWAYS, INC.
UNITED STATES
CIRCA 1931
7

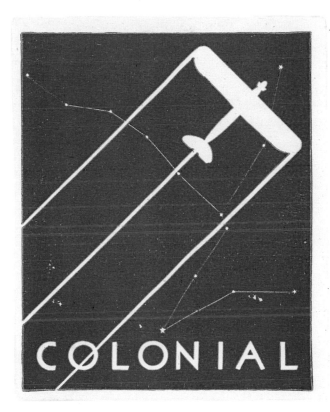

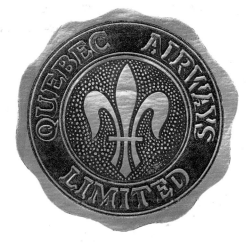

QUEBEC AIRWAYS LIMITED
CANADA
CIRCA 1935
9

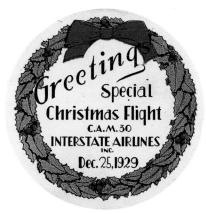

COLONIAL
UNITED STATES
CIRCA 1927
8

INTERSTATE AIRLINES
UNITED STATES
CIRCA 1929
10

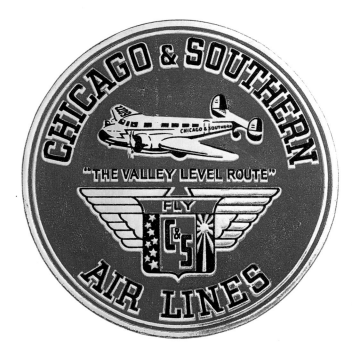

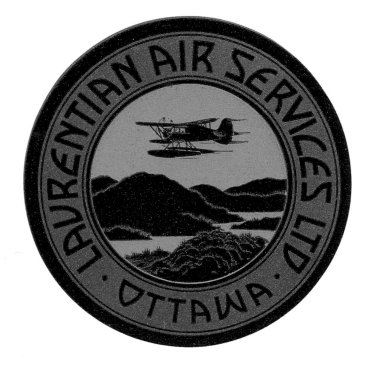

CHICAGO & SOUTHERN AIR LINES
UNITED STATES
CIRCA 1937.
11

LAURENTIAN AIR SERVICES LTD.
CANADA
CIRCA 1936
12

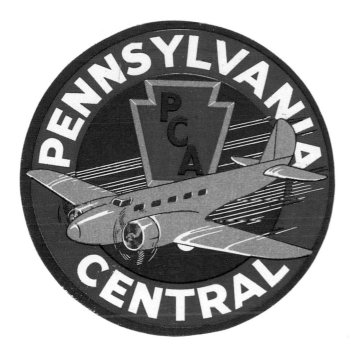

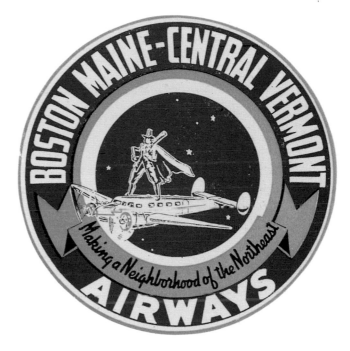

PENNSYLVANIA CENTRAL AIRLINES
UNITED STATES
CIRCA 1936
13

BOSTON MAINE-CENTRAL VERMONT AIRWAYS
UNITED STATES
CIRCA 1938
14

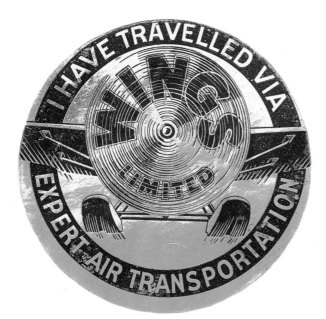

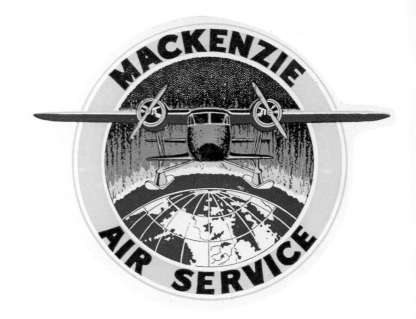

WINGS LIMITED
CANADA
CIRCA 1935
15

MACKENZIE AIR SERVICE
CANADA
CIRCA 1935
16

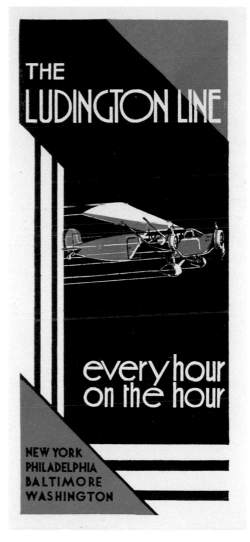

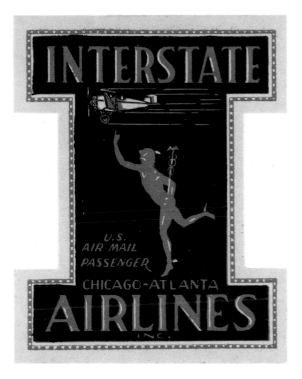

THE LUDINGTON LINE
UNITED STATES
CIRCA 1930
17

INTERSTATE AIRLINES INC.
UNITED STATES
CIRCA 1928
18

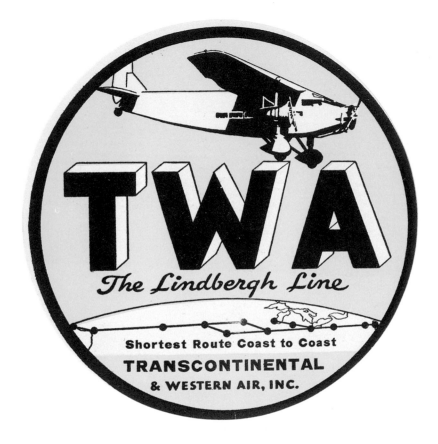

TRANSCONTINENTAL & WESTERN AIR, INC.
UNITED STATES
CIRCA 1930
19

TRANSCONTINENTAL & WESTERN AIR
UNITED STATES
CIRCA 1942
20

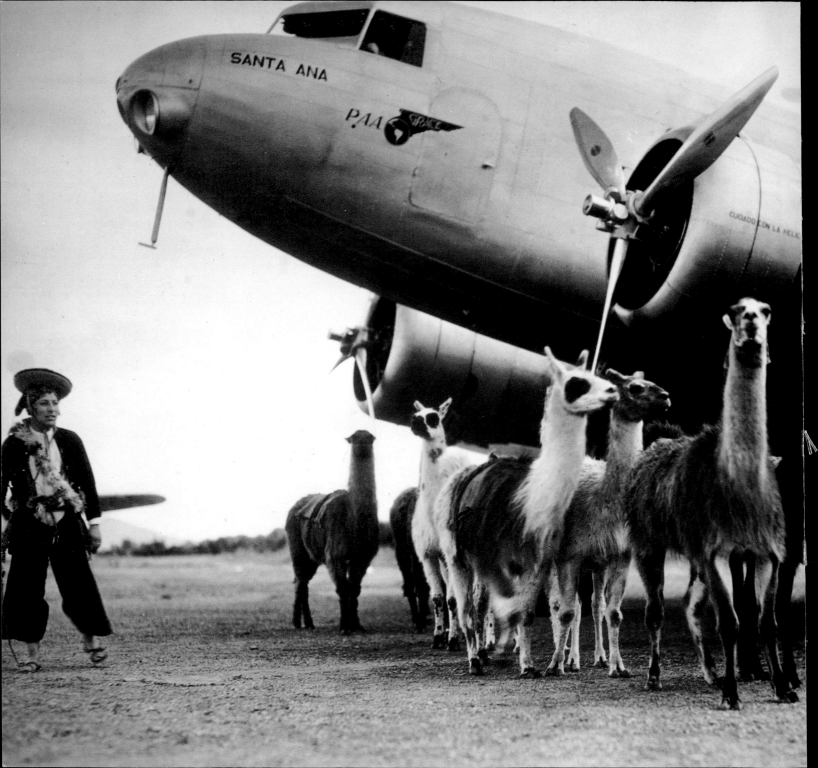

Colorful labels from Latin American airlines

During the 1920s and 1930s, American companies began to develop a variety of resorts in Latin America and the Caribbean. Initially serviced by seagoing liners, some of these locales became logical "prestige" routes for the developing airlines. In Latin America, many new airlines and routes were quickly created—often started by American, British, and German business and political interests. It is notable that many of the German-controlled routes were initiated with a military mission in mind—the Germans reasoning that if war came again with the United States, then a strong airline system under tight German control would pose a definite military advantage.

In keeping with the colorful image that most tourists have of Latin America, designers for the airlines created some of the most vividly intense of all labels. Obviously, early flights "south of the border" were arduous as well as hazardous, and during the 1920s, seaplanes were favored since there were many more landing areas in case of weather or mechanical problems. Pan American Airways System (PAA) was rapidly developing its Latin American routes (while also owning a controlling interest in

Mexicana, as well as several other "local" airlines). The two colorful PAA labels in this chapter on pages 62 and 63 depict two modes of travel—a huge Sikorsky flying boat and a cumbersome wood-and-fabric Fokker tri-motor. Both labels make use of a variety of Deco-clad passengers and flight crew getting ready for their aerial adventures. Also of note is the use of the globe with the PAA/Mexicana route superimposed. Vivid primary colors highlight both labels to give the traveler a sense of tropical splendor.

Another earlier Pan American Airways System label promoting Latin American travel is a spectacular piece of Art Deco design that would have made a magnificent full-size poster (see page 61). This label also uses primary colors to full advantage. Note that the porter is carrying a large pumpkin-like piece of luggage festooned with, what else, luggage labels! The aircraft depicted appears to be modeled after a large single-engine Fokker monoplane. The two main illustrated passengers would have done any Nick-and-Nora-Charles film proud. This particular label is almost too scarce to find in good condition but is certainly worth the search.

Some Pan American labels took on a much more

COMPANIA DE AVIACION FAUCETT
PERU
CIRCA 1948
1

Latin feeling, and these are ably illustrated by the trio of CIA. Mexicana de Aviacion labels shown on pages 58 and 59. All three of these square images feature primitive Fokker tri-motor transports droning over a variety of Mexican landscapes that include Spanish missions, local arts and crafts, and scenic locales. The designer, who is unfortunately not credited on the labels (a common flaw in virtually all label designs), created a matched set of labels that have stood the test of time to record an era when air travel was both adventurous and colorful.

Another American aeronautical concern that made strong connections with Latin America was Curtiss, which not only built airliners that were sold south of the border but also purchased large or controlling interests in some of the developing airlines. The label on page 65 is of particular interest since the Curtiss name is emphasized a great deal more than the airline, Compania Nacional Cubana de Aviacion, which takes distinct second billing. The aircraft illustrated is, oddly, not a Curtiss design but rather the ubiquitous Fokker tri-motor. After being shuttled out of North American service following the disastrous crash mentioned in Chapter Six, "They All Flew Goonies," many of the Fokkers found a new home in Latin America, where airworthiness laws were, perhaps, not as stringent. The Deco-clad porter is saddled with a collection of baggage and golf clubs that has labels of the various destinations serviced by Cubana. The well-dressed passengers were also representative of the style in which travelers dressed while flying on the early airlines.

The labels of the Latin American airlines present a brief and colorful slice of aviation history and design. Many of the labels are quite obscure today but can still be discovered in good condition. Obviously, a collection of these south-of-the-border labels can stand alone and make a very handsome presentation.

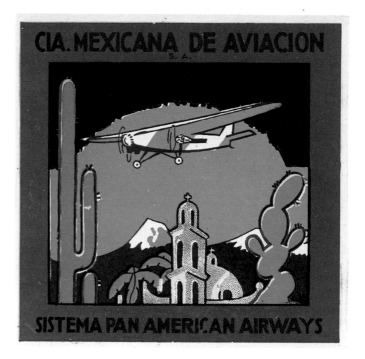

CIA. MEXICANA DE AVIACION
MEXICO
CIRCA 1929
2

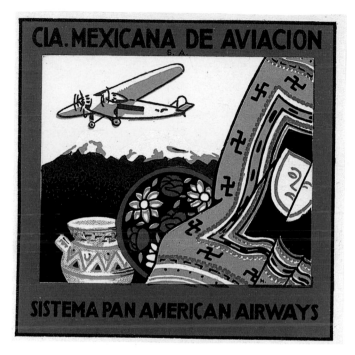

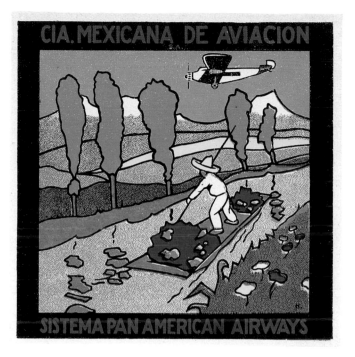

CIA. MEXICANA DE AVIACION
MEXICO
CIRCA 1929
3

CIA. MEXICANA DE AVIACION
MEXICO
CIRCA 1929
4

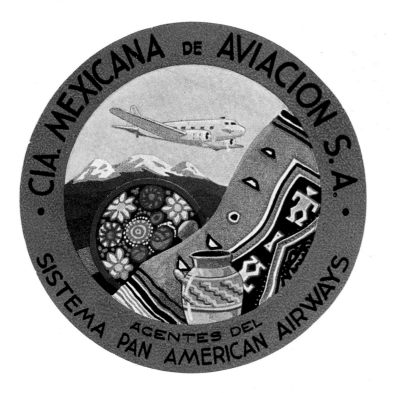

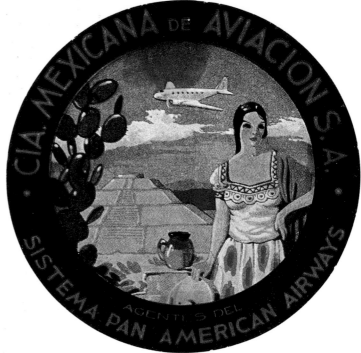

CIA. MEXICANA DE AVIACION
MEXICO
CIRCA 1939
5

CIA. MEXICANA DE AVIACION
MEXICO
CIRCA 1939
6

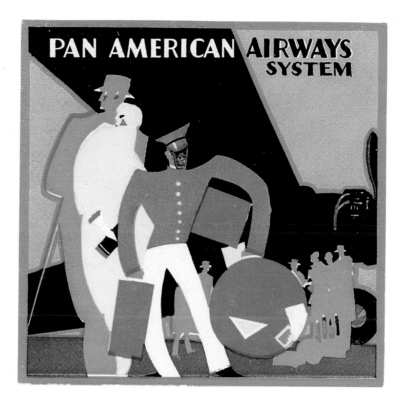

PAN AMERICAN AIRWAYS SYSTEM
UNITED STATES
CIRCA 1927
7

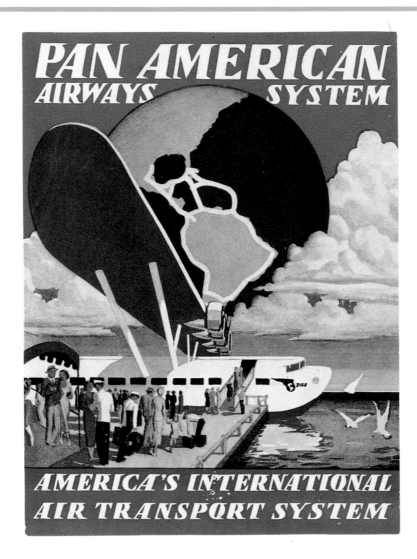

PAN AMERICAN AIRWAYS
UNITED STATES
CIRCA 1934
8

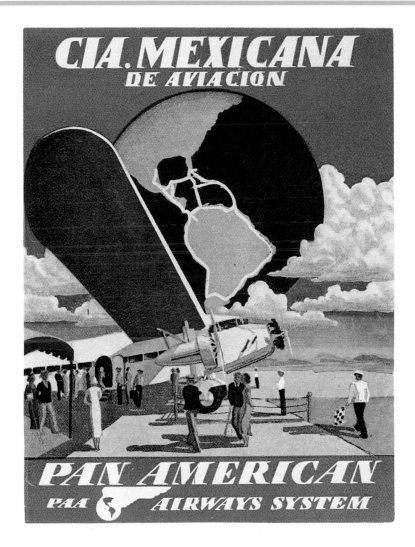

CIA. MEXICANA DE AVIACION
MEXICO
CIRCA 1930
9

SERVICIO AEREO COLUMBIANO
COLUMBIA
CIRCA 1935
10

FLOTA AEREA MERCANTE ARGENTINA
ARGENTINA
CIRCA 1946
11

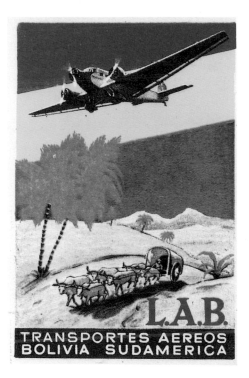

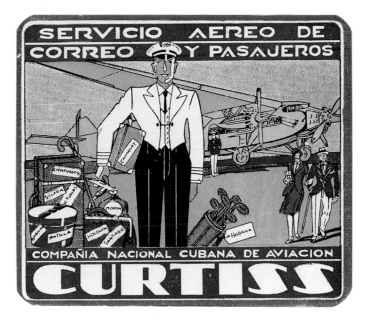

LLOYD AEREO BOLIVIANO
BOLIVIA
CIRCA 1936
12

COMPANIA NACIONAL CUBANA DE AVIACION
CURTISS, CUBA
CIRCA 1929
13

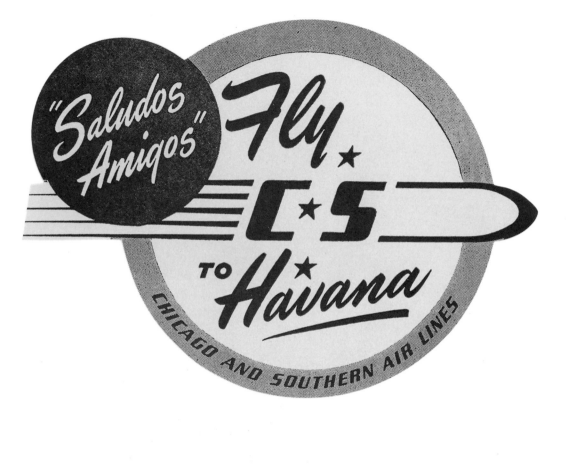

CHICAGO AND SOUTHERN AIR LINES
UNITED STATES
CIRCA 1951
14

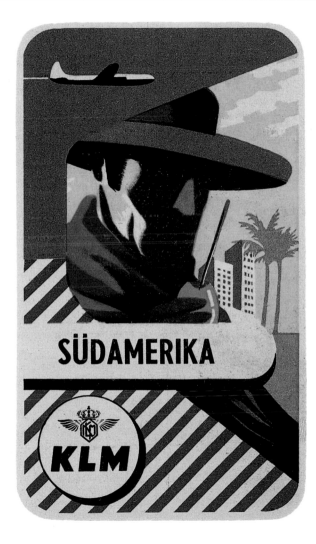

K.L.M.
THE NETHERLANDS
CIRCA 1952
15

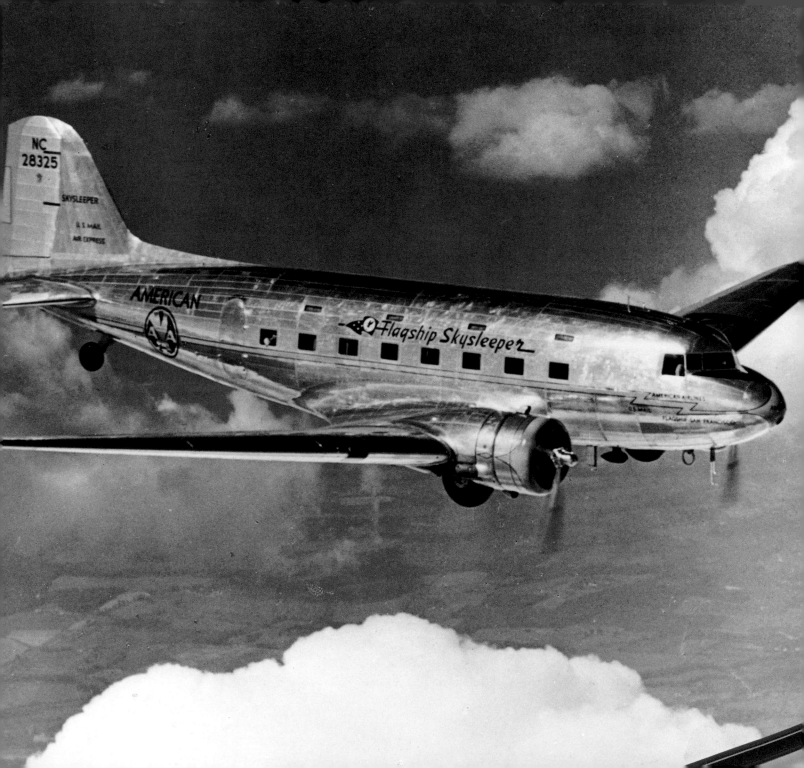

They All Flew Goonies

Labels from the airlines that operated the famous Douglas DC-3

By the mid-1930s, the airline business in the United States had settled into a dog-eat-dog affair, with a number of operators competing for passengers, airmail routes, and new cities to service. It was obvious by this time that the day of the lumbering biplane was going to be a thing of the past—faster, modern, and more efficient transports were required to expand the industry. It was also obvious that the in-flight disintegration of an all-wood Fokker tri-motor, which killed sports hero Knute Rockne, spelled doom for such wooden construction and demanded a standardization on all-metal aircraft.

In Santa Monica, California, Douglas Aircraft Co. had broken out of the biplane mold with a sleek twin-engine-all-metal monoplane transport called the DC-2 (the DC stood for Douglas Commercial). Originally built for TWA, the DC-2 was an immediate hit, and orders began coming in from other airlines. The Clover Field factory was soon churning out the gleaming metal DC-2s for a variety of operators, and the type became a near-instant success for passenger appeal and airline profitability.

American Airlines, one of the newer airlines, had seen the success of the DC-2 and approached Douglas with the proposition of building a larger variant of the DC-2, which American could operate on its transcontinental sleeper service. At the time, American was operating Curtiss Condor biplanes, which were reliable and quite roomy but slow. TWA was taking business away from American, who knew it had to obtain more modern equipment to survive. At first, Douglas was skeptical about working with the new airline, but after American obtained a $4,500,000 loan from the Reconstruction Finance Corporation, a deal was made whereby Douglas would begin work on the new sleeper transport.

The company originally envisaged a plane that would use eighty-five percent parts from the DC-2 and fifteen percent new parts to save both time and money. As the designers got more into the project, however, they found that although the basic general layout of the DC-2 could be retained, the percentages would be almost reversed—ten percent DC-2 parts and ninety percent new parts. Construction of the new plane

AMERICAN AIRLINES
UNITED STATES
CIRCA 1932
1

American's DST service began on September 18, 1936, with coast-to-coast service between Newark, New Jersey, and Grand Central Air Terminal, Glendale, California. At that time, Grand Central was the main airline terminal for the Los Angeles area. Although Grand Central is no longer an airfield, its magnificent Art Deco terminal building still survives. To illustrate the impact on American's service, in 1934 it took twenty-four hours and fifty-five minutes, a change of airlines, two changes of aircraft, and a stunning fifteen stops to fly between New York and Los Angeles. With DST service, American was able to have a single plane stopping only three times to cross the nation in seventeen hours and thirty minutes.

began in December 1934 while the engineering and drawing of plans was still underway. By mid-1935, American and Douglas came to an agreement concerning the final product, and American placed an initial firm order for ten DSTs (Douglas Sleeper Transports).

Powered by two Wright Cyclone engines, each developing a maximum of one thousand horsepower for takeoff, the first DST took to the air on December 17, 1935—indicative of just how fast American industry worked during that time. The DST could accommodate fourteen passengers in night configuration; seven of the seats could be made into beds, and seven fold-down berths could be swung from the ceiling. This procedure was extremely innovative and became very popular with American's passengers.

IN ORDER TO CAPITALIZE ON ITS SPEEDY DC-3 SERVICE, AMERICAN AIRLINES STYLED ITS ON-BOARD SILVERWARE TO INCLUDE A MODERNE IMAGE OF THE COCKPIT OF A DC-3. COLORFUL BROCHURES WERE ALSO DESIGNED TO ATTRACT THE TRAVELER. AMERICAN'S "SUN COUNTRY" ROUTE TO ARIZONA, TEXAS, AND SOUTHERN CALIFORNIA HIGHLIGHTED THE USE OF DOUGLAS "SLEEPER" TRANSPORTS.

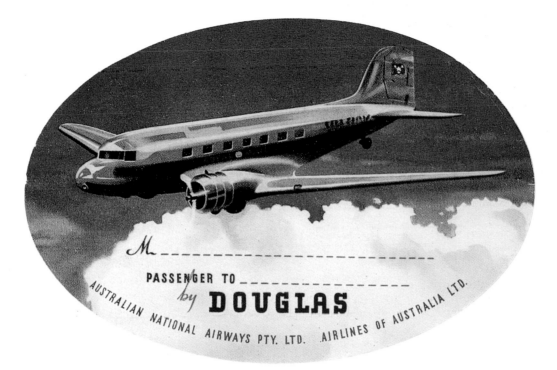

AUTRALIAN NATIONAL AIRWAYS PTY. LTD.
AUSTRALIA
CIRCA 1937
2

TAXIS AEREOS NACIONALES SA
MEXICO
CIRCA 1946
3

ZONAS OESTE Y NORTE DE AEROLINEAS ARGENTINA
ARGENTINA
CIRCA 1946
4

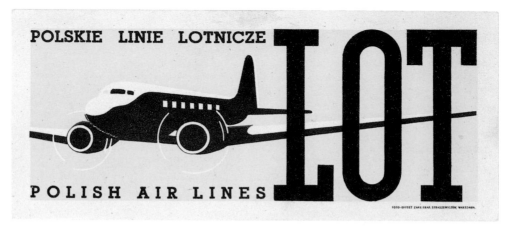

POLSKIE LINIE LOTNICZE
POLAND
CIRCA 1938
5

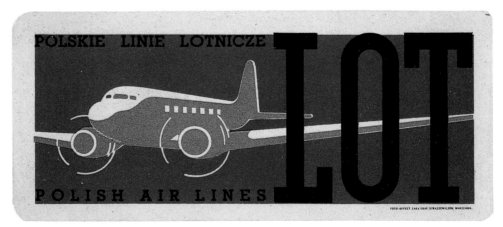

POLSKIE LINIE LOTNICZE
POLAND
CIRCA 1938
6

FUNDADA EN 1919

VIA
Sceadta
LA RUTA DE LA
CONFIANZA
COLOMBIA-SUR AMERICA

LIT. BARRANQUILLA

SOCIEDAD COLOMBO ALEMANA DE TRANSPORTES AEREOS
COLUMBIA
CIRCA 1938
7

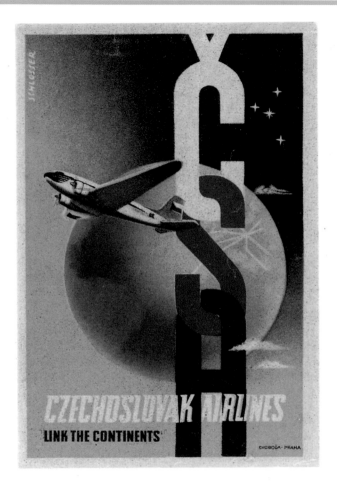

CZECHOSLOVAK AIRLINES
CZECHOSLOVAKIA
CIRCA 1950
8

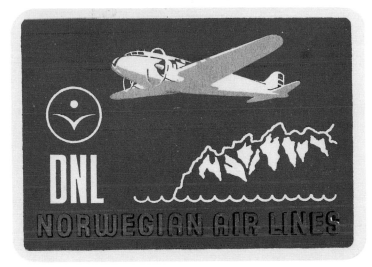

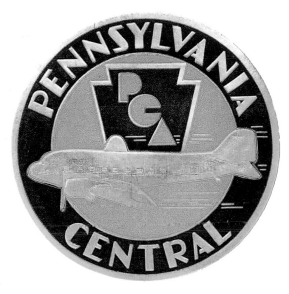

NORWEGIAN AIR LINES
NORWAY
CIRCA 1946
9

PENNSYLVANIA CENTRAL AIRLINES
UNITED STATES
CIRCA 1938
10

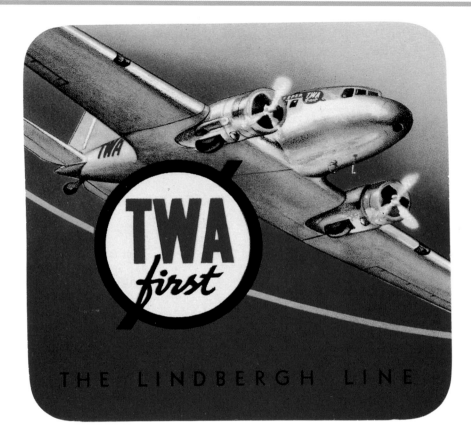

TWA
UNITED STATES
CIRCA 1937
11

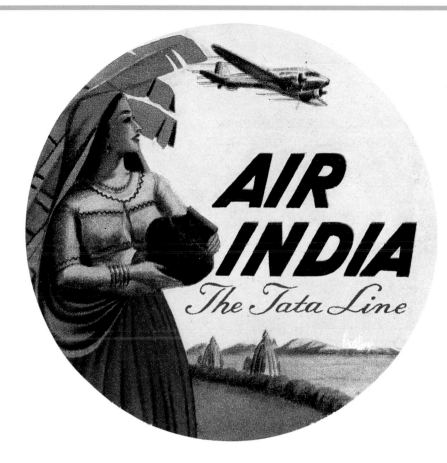

AIR INDIA
INDIA
CIRCA 1946
12

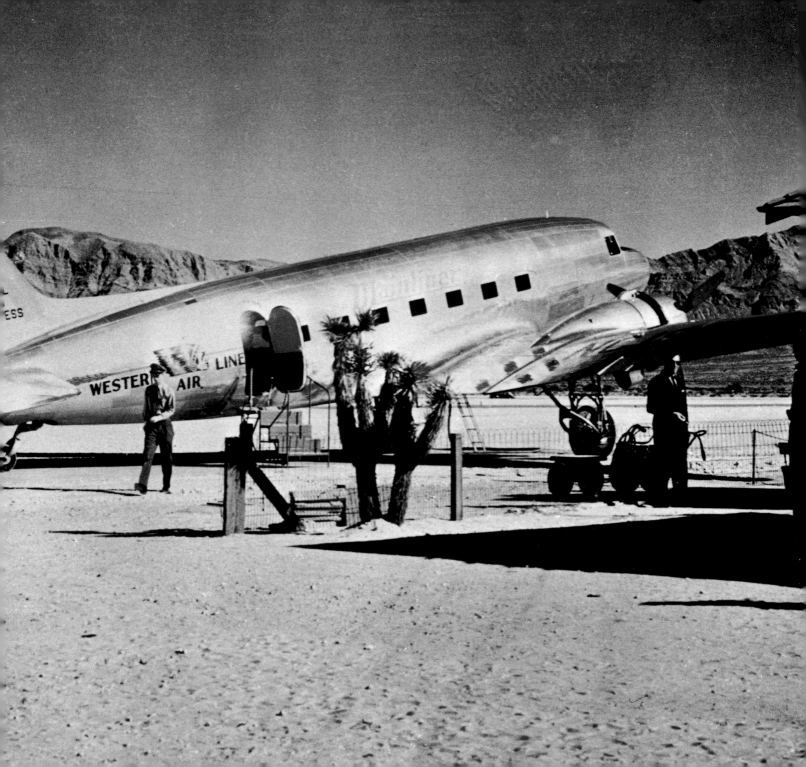

Way Out West

Labels from the airlines that serviced the western United States

The development of the early airlines in the United States faced a number of vexing problems, including a lack of suitable aircraft, varying weather conditions, and often-treacherous terrain. All these conditions were present in the western states, where conditions could range from blistering deserts to soaring, snow-capped mountains—often in the space of just a few miles. Air transport was essential to the development of the western part of the country, since many locations were not reachable by road or rail. Overcoming obstacles with then-current technology was a challenging proposition for even the hardiest American pioneering spirit.

Early equipment comprised a variety of surplus Great War military aircraft converted to civilian needs and an increasing variety of rugged single- and tri-motor aircraft specifically built for strenuous operations in the more primitive environments. These planes were being built by new aeronautical concerns such as Ford, Stinson, Fokker, and Bellanca. Since superchargers for aircraft engines were still in the future, most flights that had to cross mountain ranges like the Sierras or the Rockies had to carefully thread their way through the lowest valleys, with engines usually at full throttle to maintain even minimum flying speed in the rarefied air. Needless to say, such flights were commonly thrilling and often dangerous. If an aircraft crashed or was forced down, passengers would usually have to rely on luck for their rescue, since aerial radios were still in the pioneering stage and most aircraft in the 1920s were not fitted with such "sophisticated" equipment.

For these early western airlines, existence was usually on a hand-to-mouth basis, and any sort of business was accepted—hauling anything from mining equipment to livestock to passengers to, it was hoped, a lucrative government airmail contract. Even though conditions were harsh and aircraft basic, the early airlines forged ahead, and this dogged pioneering spirit is well represented in the Wyoming Air Service label on page 84. The western spirit is presented by the designer as a cowboy on a rearing horse, silhouetted against the rays of a rising sun, while an early cabin monoplane flies overhead. The label is evocative of the old saluting the new.

As time progressed and airline mergers and takeovers became more common, Wyoming Air Service became Inland Airlines, which started

WESTERN
AIR LINES

25th
YEAR

WESTERN AIR LINES
UNITED STATES
CIRCA 1966
1

operating modern and dependable twin-engine Boeing 247Ds in 1938. Interestingly, Inland's label retained the image of the cowboy but set him against the dramatic terrain over which the 247 operated. An added design touch is the set of stylized wings around the border of the label.

One of the more attractive way-out-west labels is shown on page 88. Standard Airlines called itself "The Fair Weather Route" and then went on to list its route from Los Angeles to El Paso. Finished in dramatic deep purple and orange, the label takes full advantage of presenting the airline's name in bold Deco lettering. The purple carries through to the aircraft, a Fokker Super Universal tri-motor, which shows passengers and luggage being taken on board.

The spirit of the west is again well represented in a label on page 89 for National Parks Airways, which serviced Utah, Montana, and Idaho. Using a triangular shape, the label features an early cabin monoplane overflying some very hostile terrain while an Indian warrior looks on. The label also proclaims "Carried by Air," which would have added a certain panache to any piece of 1920s luggage.

Another scarce label is the one issued by Gilpin Airlines, whose route went between Los Angeles and San Diego, with stops at Agua Caliente and Long Beach. It is interesting that the designer listed the stops on the label but then also added a small illustration appropriate to each location. Gilpin, apparently interested in keeping its operation local, flew a curious limited-production aircraft called the Bach tri-motor built in Van Nuys, California.

The labels of the airlines that serviced the western states are highly collectible and offer a variety of images from immediately after the Great War into the 1950s (as evidenced by the "Dale Evans" Trans-Texas Airways label). Within these three decades, the western states were transformed from a rather remote area into the center of American prosperity, with a good deal of the credit going to the airlines.

WESTERN AIR EXPRESS
UNITED STATES
CIRCA 1928
2

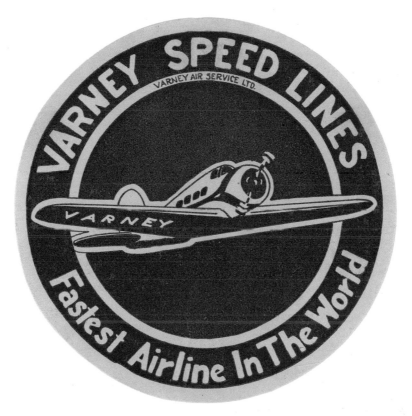

VARNEY SPEED LINES
UNITED STATES
CIRCA 1934
3

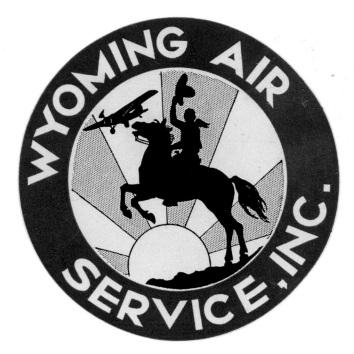

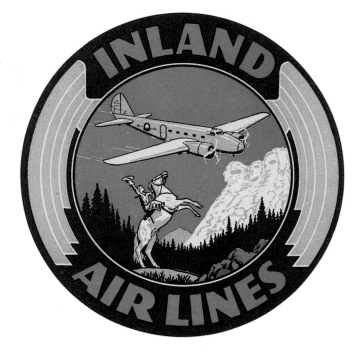

WYOMING AIR SERVICE, INC.
UNITED STATES
CIRCA 1930
4

INLAND AIR LINES
UNITED STATES
CIRCA 1938
5

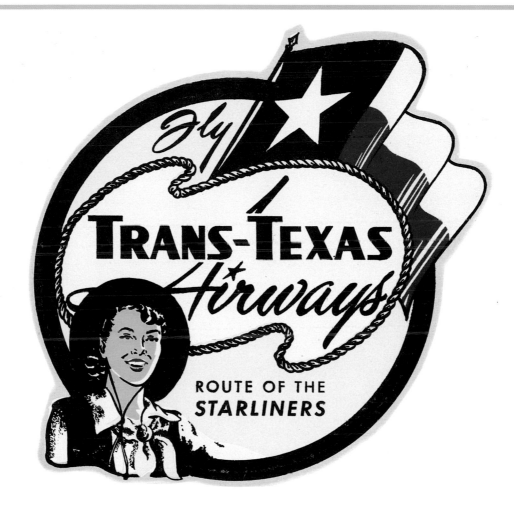

TRANS-TEXAS AIRWAYS
UNITED STATES
CIRCA 1947
6

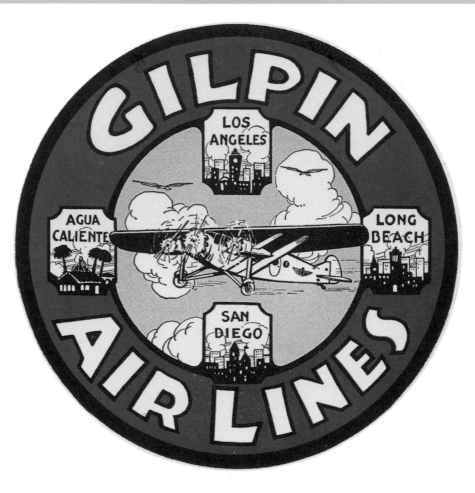

GILPIN AIR LINES
UNITED STATES
CIRCA 1930
7

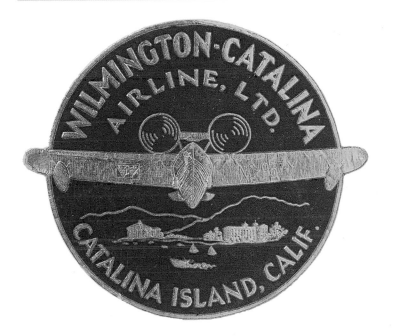

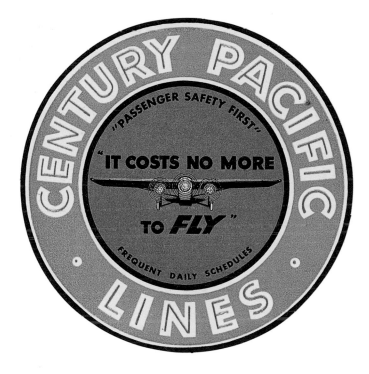

WILMINGTON-CATALINA AIRLINE, LTD.
UNITED STATES
CIRCA 1931
8

CENTURY PACIFIC LINES
UNITED STATES
CIRCA 1931
9

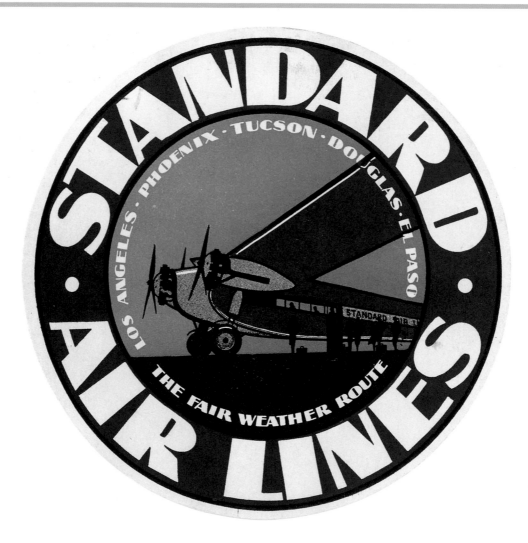

STANDARD AIR LINES
UNITED STATES
CIRCA 1927
10

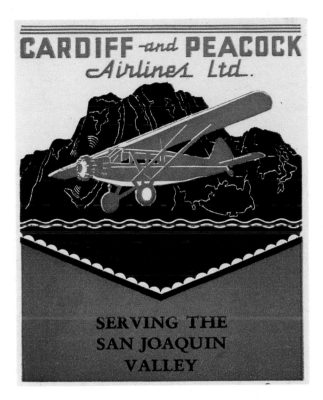

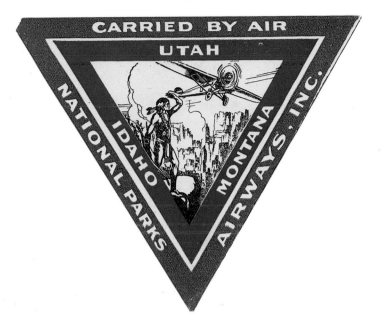

CARDIFF AND PEACOCK AIRLINES LTD.
UNITED STATES
CIRCA 1933
11

NATIONAL PARKS AIRWAYS, INC.
UNITED STATES
CIRCA 1929
12

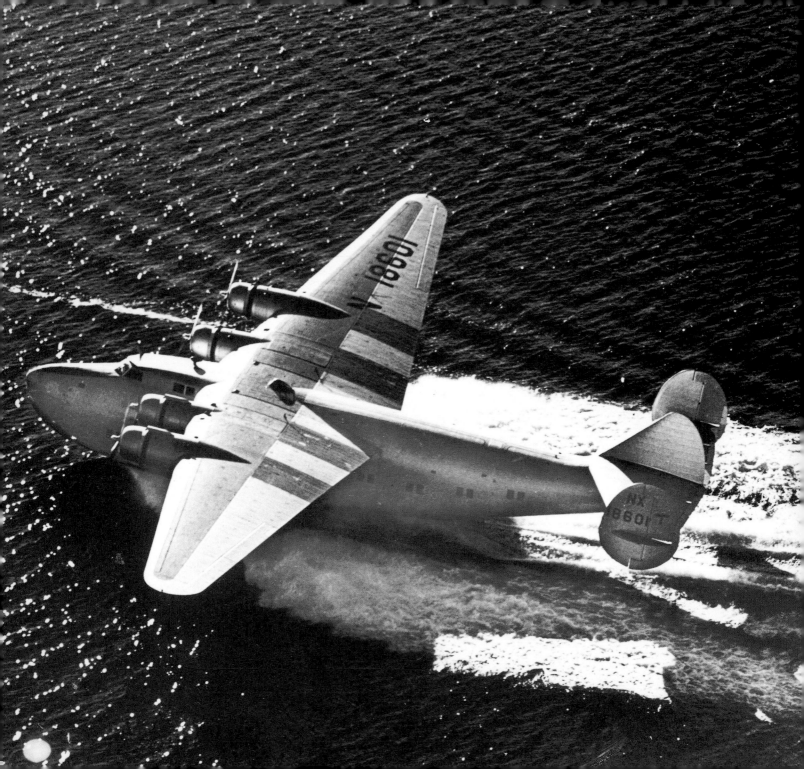

Labels from strange and exotic locations

If early airline flying could be summed up in one word, that word would be *adventurous*. The hardy passengers that braved the discomforts, primitive machinery, erratic schedules, and the dozens of other problems that were a daily part of early aviation must have been an eclectic lot that let little stand in their way. However, as flying and the airlines became more firmly established, it was evident that aircraft could be used to visit some of the most exotic locations. Airlines began to open up areas that were previously off-limits except for perhaps the bravest of explorers, and airline labels began to reflect that fact.

The Western Australian Airways label on page 100 makes good use of the image of a searchlight, a feature popular in Art Deco. The label exhorts the traveler not only to travel by air but to mail by air also. Much of Australia is composed of extremely harsh terrain, and air travel over the vast deserts or mountain areas in early aircraft was always a bit of a white-knuckle affair. However, it was also the only way of getting from point A to point B quickly. As the label aptly states on its Perth-Adelaide route, Western Australia Airlines was "Quicker by Days."

Travelers on Guinea Airways Ltd. were probably pleased that the company featured a few tri-motor aircraft among its small fleet. After all, the chance of an engine failure while flying over some of the remote and dangerous New Guinea terrain could pose a distinct problem—especially since some of the locals would consider travelers falling from the heavens an excellent main course. The label for this carrier, on page 100, shows an attractively stylized tri-motor aircraft. Although the label background is rather somber, it does stress "Dependable Transport Always"— a statement that probably brought a measure of comfort to the traveler.

The label designer for Trans Asiatic Airlines was apparently given a free hand to create an image that would promote the exotic locales serviced by the airline. To that end, the label uses pastel colors to effect while combining images of a traditional oriental dancer, a vintage

PAN AMERICAN WORLD AIRWAYS
UNITED STATES
CIRCA 1950
1

junk in a romantic harbor setting, lush foliage, and, strangely, a topless dancing girl in a grass skirt swaying to the music from a relaxed guitar player. All these elements make this one of the more exotic labels.

After World War II, Universal Airways was established to fly Jews and survivors of the Holocaust from the newly formed state of Israel to South Africa and other stops in between. The label illustrates a one-way-street sign that gives little doubt about the tie between the two countries. The sign is mounted on a map of Africa and the Middle East. The predominant blue-and-white coloring and the Star of David confirm the strong religious overtone of the airline that helped resettle a shattered European Jewish population.

For the more experienced air traveler, flying boats have always held a certain fascination, since the aircraft did not require a surfaced runway and thus could venture to many exotic lands. Because of this appeal, it is not unusual to find labels with a flying boat as a main design image. Qantas Empire Airways flew Irish-built Shorts flying boats on their grueling Sydney-to-London service before and after the Second World War. The label on page 95 makes use of the strong image of a head-on flying boat in dynamic red, while the concentric circle background is surely a play on the wartime roundel insignia carried by Royal Australian Air Force combat aircraft. The Sydney-to-London route, while arduous, was quite popular since it shortened the normal sea journey by well over a week.

Tasman Empire Airways Ltd. (TEAL) also made use of the Shorts Empire flying boats that covered the twelve hundred-mile journey between Auckland and Sydney in nine hours—a very significant improvement over the sea crossings. The silver and red label on page 94 also makes use of a head-on view of the four-engine flying boat while the word "Tasman" is surmounted by silver stylized wings that seem almost Egyptian in their execution.

It was obvious that the more exotic or daring the destination, the more passengers used the labels as proof of their worldliness or adventuresome nature. The airlines took full advantage of this fact, and their labels show how the remote areas of the world had become accessible with modern air travel.

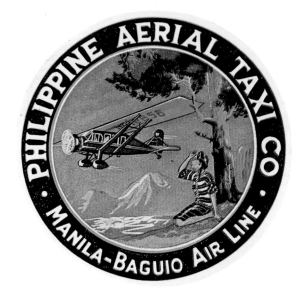

PHILIPPINE AERIAL TAXI CO.
PHILIPPINES
CIRCA 1931
2

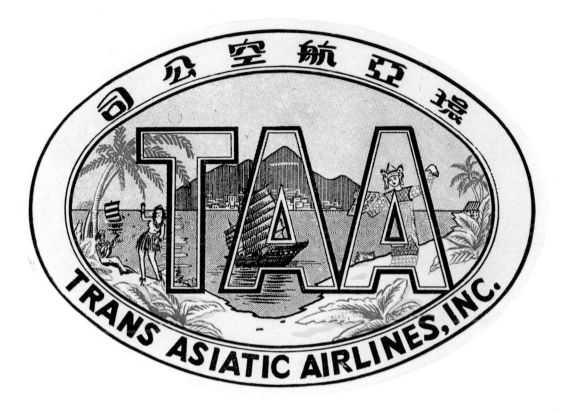

TRANS ASIATIC AIRLINES, INC.
SIAM (THAILAND)
CIRCA 1948
3

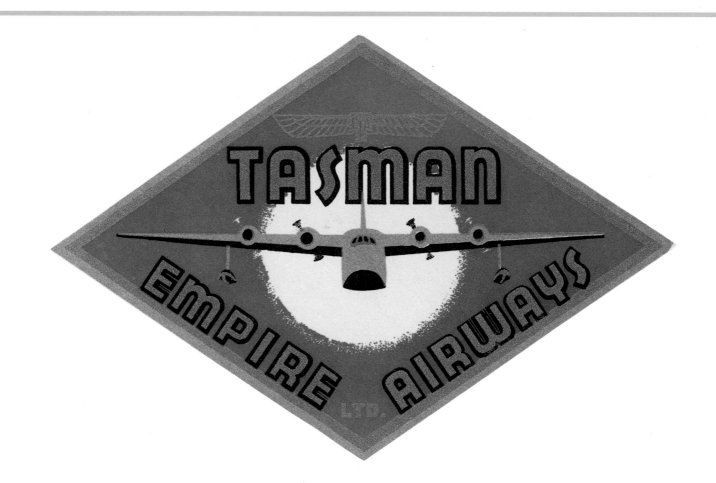

TASMAN EMPIRE AIRWAYS LTD.
AUSTRALIA
CIRCA 1940
4

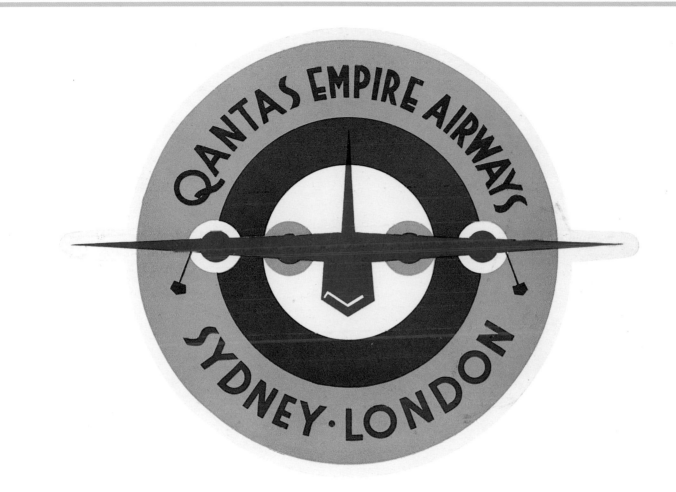

QANTAS EMPIRE AIRWAYS
AUSTRALIA
CIRCA 1938
5

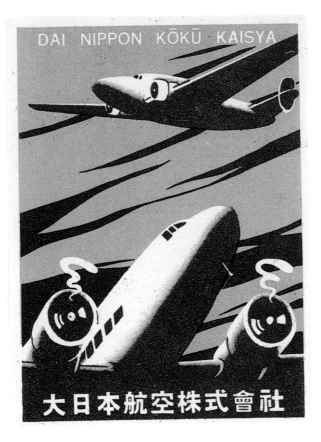

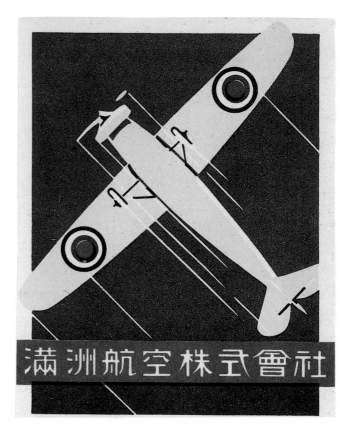

DAI NIPPON KOKU KAISYA
JAPAN
CIRCA 1940
6

MANCHURIAN AIR TRANSPORT
MANCHURIA
CIRCA 1932
7

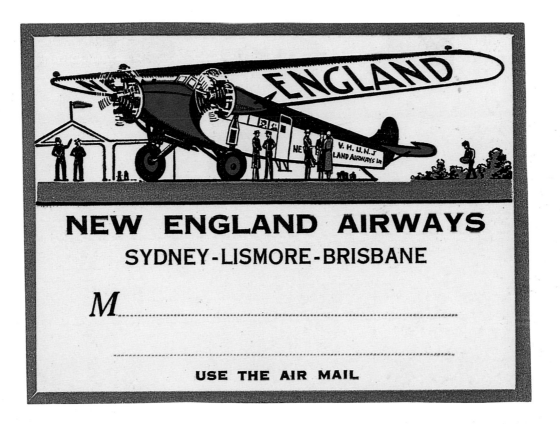

NEW ENGLAND AIRWAYS
AUSTRALIA
CIRCA 1931
8

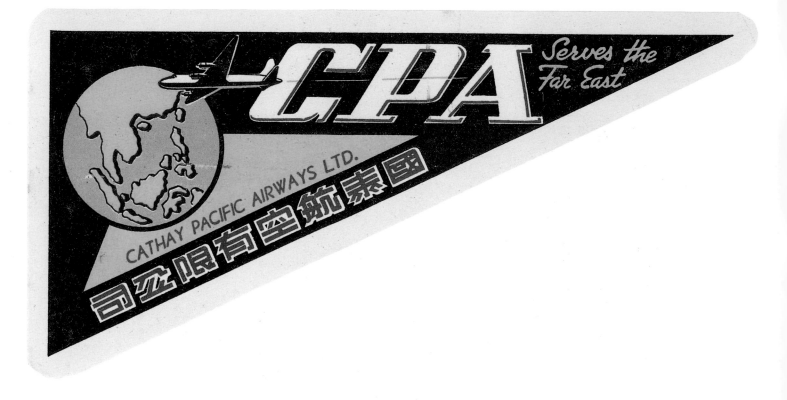

CATHAY PACIFIC AIRWAYS LTD.
HONG KONG
CIRCA 1946
9

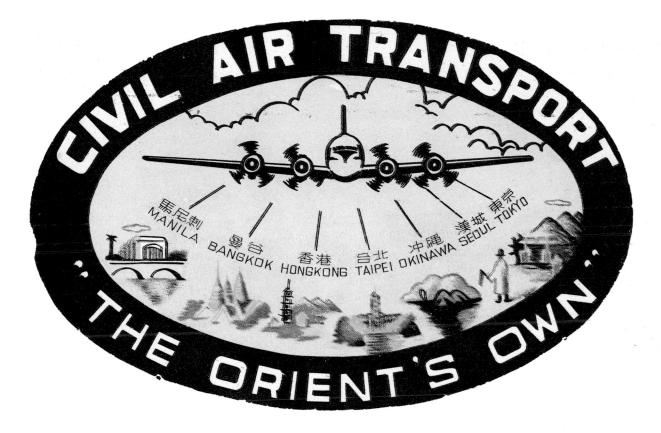

CIVIL AIR TRANSPORT
CHINA
CIRCA 1948
10

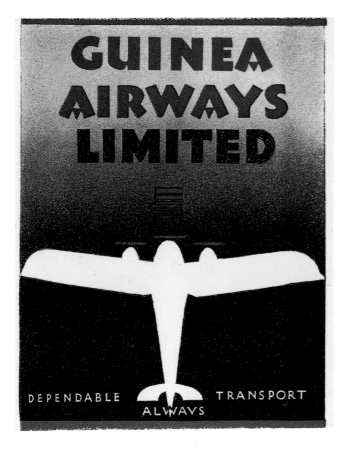

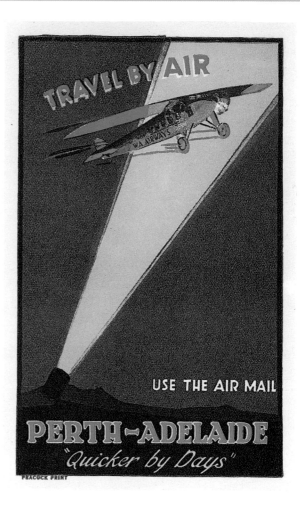

GUINEA AIRWAYS LIMITED
NEW GUINEA
CIRCA 1927
11

WESTERN AUSTRALIAN AIRWAYS LTD.
AUSTRALIA
CIRCA 1929
12

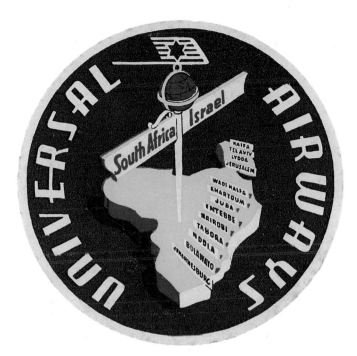

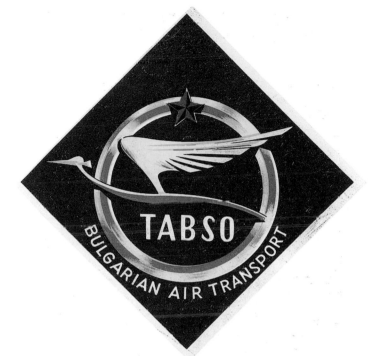

UNIVERSAL AIRWAYS
SOUTH AFRICA
CIRCA 1946
13

BULGARIAN AIR TRANSPORT
BULGARIA
CIRCA 1949
14

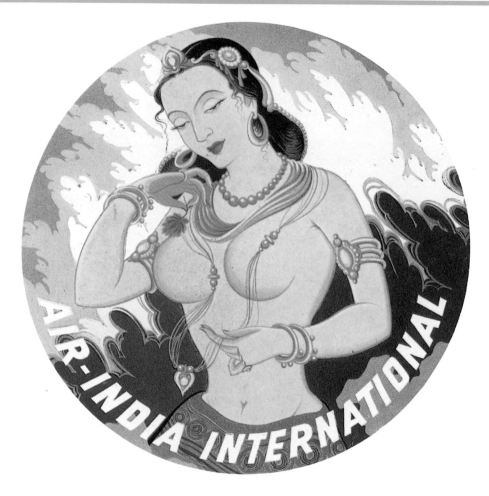

AIR-INDIA INTERNATIONAL
INDIA
CIRCA 1960
15

 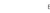

AUSTRALIAN NATIONAL AIRWAYS
AUSTRALIA
CIRCA 1950
16

Collecting Vintage Labels

How to acquire and preserve a collection of vintage airline labels

The popularity of collecting has grown tremendously in the United States during the past two decades. It almost doesn't matter what is being collected; there are usually sources, collectable shows, books, and magazines on the particular subject. The scope of collecting ranges from Elvis memorabilia to magnificently restored vintage juke boxes. Collectibles are usually from this century, since the twentieth century has produced more items than all other periods of civilized history combined. This sheer volume has allowed the collector to choose from many hundreds of subjects—from beer cans to Aunt Jemima items. Also, the temporary nature of many of these products meant that the vast majority were disposed of after initial use, ensuring that the task of acquiring is an enjoyable one for today's collector.

Paper items—the most popular being postage stamps—are widely collected. The first adhesive postage stamps were issued in 1840, and it was not long before collectors began gathering and collating the rapidly increasing number of stamps issued around the world. Today, the philatelist is thought to be the most numerous of collectors. One trade journal has estimated that there are over fifty million stamp collectors in the world—a tremendous number that has produced a very well-organized hobby, with dozens of magazines and hundreds of books on the subject. The advanced organization of such a hobby has also developed a definite value system for the item being collected. Thus, it is not uncommon for investment houses to include rare and appreciating stamps in their portfolios.

Labels of all types have become extremely popular with collectors, starting in the late 1960s with "orange crate" labels, which were originally applied to citrus boxes. The discovery during 1967 of several large warehouses of unused labels put tens of thousands of labels on the collectors' market. These labels, which are often printed in more than six colors and feature extremely attractive graphics and design, also were heavily

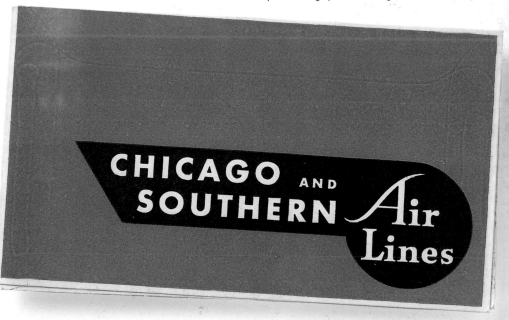

used for interior decor. Orange crate labels became the impetus for collecting many other forms of paper "art."

There are several reasons why labels of any form are collected. Social historians use labels as an indicator of the time period they were used and quite often collect the items to which the labels were affixed to put the whole package in proper historic perspective. Graphic designers often collect labels as a source of documentation for art work and to inspire current projects. Art enthusiasts enjoy labels for their complex and attractive art and because some labels were executed by famous illustrators.

In recent years, we have seen an expansion of interest in labels that are viewed, often incorrectly, as representing simpler, less threatening times. Such labels often depict luxury services, including fine hotels, steamship lines, and the early airlines.

Each of these categories probably does express a time when wealth brought with it an expectation of unparalleled luxury and service. Also, the wealthy (along with the not-so-wealthy having a chance to share in the same experience) were not above plastering their expensive luggage with labels that were strong indications of their position in a class-conscious society.

With the advent of World War II, however, many of the world's great hotels were either captured or destroyed by opposing forces. The huge ocean liners were usually taken over by the military and used for troop and cargo transport, also becoming excellent targets for submarines. The emerging commercial airline system was usually also militarized or destroyed by opposing forces. With the successful conclusion of World War II by Allied forces, a more democratized free world emerged, and many of the social barriers simply disappeared. Along with this democratization, a certain style of life either went away or became less ostentatious.

The war years not only brought massive destruction but also, in many areas of technology, massive development and progress. Before the war, for example, the only aerial way of crossing the Atlantic or Pacific was by the Pan American

ITINERARY

M_____

YOUR CAR LEAVES FROM_____AT_____PM AM
(PASSENGERS DRIVING TO AIRPORT IN OWN CARS PLEASE ARRIVE 15 MINUTES BEFORE PLANE DEPARTURE TIME)

YOUR PLANE LEAVES FROM_____AT_____PM AM

FLIGHT NO._____DATE_____FARE $_____

CONFIRM YOUR RETURN RESERVATION ON ARRIVA_____

BY TELEPHON_____

CHICAGO & SOUTHERN Air Lines

Faster Transportation between Chicago and the Gulf

THE VALLEY LEVEL ROUTE

THE BOLD ORANGE AND BLACK CHICAGO AND SOUTHERN AIR LINES TICKET HOLDER OPENS TO REVEAL PASSENGER INFORMATION ALONG WITH A NEATLY ENCLOSED BAGGAGE LABEL.

Boeing Clipper—a magnificent Art Deco flying boat. Only a few of these planes were built, however, and the infrequent service was restricted to a very few of the wealthy or to those on important government business. At this time, the era of the ocean liner was still in full swing.

Aviation progress during the war meant that ocean crossings by a new generation of four-engine, propeller-driven landplanes were now fairly common, eclipsing the usefulness of both the flying boat and the ocean liner. From 1945 on, air travel rapidly became the accepted mode of travel, and much of the glamour associated with passenger flying simply disappeared. By the time jet passenger service was initiated during the 1960s, the golden age of label art was also pretty much a thing of the past.

Since label collecting is relatively new, most prices remain fairly low. A beginning collector can expect to pay from fifty cents to one hundred dollars for the rarest and most desirable of airline labels. Between these two extremes are fantastic arrays of prices, time periods, and styles.

How does one get into collecting airline labels? There are many different ways. Most major cities now host regular collectible shows, where one can find dealers who handle different categories of labels, including those featuring airlines and airliners. Several books have been published on collecting items relating to air travel, one of the most useful being *Commercial Aviation Collectibles* by Richard R. Wallin (Radnor, Pennsylvania: Wallace-Homestead Book Company, 1990).

There is even a six-volume listing of airline labels titled, logically enough, *Air Transport Label Catalog*, put out by the Aeronautical & Air Label Collectors Club (P.O. Box 1239, Elgin, Illinois 60121-1239). Although bringing new meaning to the term *amateur*, the volumes are full of useful information. The club is the umbrella group for a number of other unusual clubs that include, according to the masthead, the Ethiopian Collectors Club of America, Rocket Mail Society, and Zeppelin Collectors Club.

As with any vintage paper product, the condition of a label determines its value. Beginning collectors should go after labels in perfect, or "mint," condition. Labels with tears, stains, or faded colors often have little or no value. There are many airline labels

still available in mint condition—even those going back to the early 1920s.

Once obtained, many labels can be stored in a three-ring notebook binder and arranged according to subject matter or collector's choice. Most photographic supply stores carry a wide variety of clear pages divided into different size compartments into which labels can be inserted for display. Care should be exercised in obtaining pages that are clearly marked "Archival," since these do not contain harmful polyvinyl chlorides (PVCs), which will damage the labels. If labels are being purchased for investment value, they should never be glued or mounted on paper pages, because this will virtually negate their value. Since these are vintage items, labels should not be exposed to extreme heat or sunlight. Many labels are so inexpensive, however, that they can be affixed to luggage, camera cases, etc. for that "well-traveled" look.

Explanation of Labels

The Fledgling Takes Wing

1, 7, 9) France was an aggressive nation when it came to aviation, so it is not surprising that soon after the devastating Great War, a concern of French businessmen perceived the need for a national service to cross the English Channel. Formed in 1923, Air Union focused on developing the Paris-to-London route. However, by 1926 Air Union was flying all the way to North Africa. The first label (1) advertises the company's new "Golden Ray" service which was an upscale flight inaugurated in 1927 that used young stewards recruited from posh London hotels. A lumbering Farman biplane is illustrated in a streamlined fashion, while a streak of fifth-color gold bisects the label to give added emphasis to the new service. "Paris-London" is printed on the label, but "London-Marseilles" has been overstamped by hand, giving an indication of the expansion of the route. The second Air Union label (7), in an attractive triangle shape, lists the company's various offices—complete with telephone numbers—while a huge Farman biplane is seen over stylized clouds. The third Air Union label (9) is a bold Deco statement in geometric patterns and bright colors. The number in the lower right corner indicated destination. For example, 7 meant London.

2) Czechoslovakia has a long and proud aviation history. Ceskoslovenske Statni Aerolinie (CSA) began operation in 1923, with the majority of routes flying toward the east. Indigenous air transport biplanes carried small loads of passengers and cargo over such "haunted" areas as the Carpathians (home of Vlad the Impaler, more commonly known as Count Dracula) to establish firm service to Poland and Russia. The label shows a large single-engine biplane with a stylized Deco-inspired rendition of Mercury imposed over the craft.

3) Early airlines often attempted to capitalize on the areas from which they operated, but one of the more curious examples is this little label from Furniture Capital Air Service. Beginning operations in 1930 from Grand Rapids, Michigan (which, at the time, proclaimed itself to be America's "furniture capital"), the little line was basically an air taxi/charter service that operated "Open and Closed Cabin Planes" with a Ryan monoplane look-alike on the label. Apparently, all those furniture magnates had little desire to go aviating, and the service was taken over by Kohler Aviation Corp. in 1931.

4) This particular label is of interest on several points. First, the importance of airmail to the financial success of the early airlines is highlighted by the traditional airmail red, white, and blue stripe crossing the bottom portion of the label, with the legends "U.S. Air Mail" and "Air Travel" printed in the white stripe. Second, the top portion of the label has been die-cut to follow the outline of the plane's wing and background landscape. Third, the busy art work shows a variety of Deco-clad passengers (the large red suitcase is plastered with labels!) entering a Curtiss Condor biplane, and the detail is fine enough to see that the hangar in the background is emblazoned with the company name. The company began as Pitcairn Aviation, but, in 1929, Harold Pitcairn, who was more interested in his flying school, sold out to North American Aviation, who renamed the airline Eastern Air Transport. Eastern began scheduled passenger service in August 1930 and pioneered passenger comfort. Because Curtiss was also a subsidiary of North American, Eastern soon standardized on the Condor. The Condor was rather cumbersome but it was reliable, quiet, and comfortable. In February 1934, all existing airmail contracts were cancelled and EAF emerged as Eastern Air Lines.

5) Formed in 1925, National Air Transport was one of the first airlines created to carry passengers. As the slogan "Flying with the Air Mail" on the label proudly announces, carrying the US Air Mail was a big part of the company's revenue. In 1930, NAT was absorbed by United Air Lines.

6) This extremely quaint label illustrates a primitive monoplane while proclaiming Hoosier Airplane Lines milestones of "1923 Charter" and "1924 Air Taxi." The small line covered Indiana destinations such as Fort Wayne, Muncie, Indianapolis, Vincennes, and Terre Haute. It is thought that the company did not last more than a couple of years, but it certainly was one of the earliest mid-America operators.

8) Created by Larkin Aircraft Supply, Australian Aerial Services Ltd. started operating a weekly Queensland-Northern Territories service in 1930. The airline was taken over in 1930 by Qantas. This label illustrates a stylized post-war de Havilland monoplane droning over a rather pastoral landscape.

10) Sir Charles Kingsford-Smith, the famed record-setting Australian aviator, began Australian National Airways Ltd. in early 1930. The fleet included four Fokker 10s that flew a popular daily service between Sydney and Brisbane (a five-hundred-mile journey). Sadly, one of

the Fokkers disappeared in the vast outback, and the adverse publicity caused an understandable decline in passengers. The company folded several months later. This brash label promotes an aerial freight service with a Fokker tri-motor and is packed with information on agents. Kingsford-Smith later disappeared without a trace on a transpacific-record flight attempt.

11) To increase its route system, United Air Lines began to acquire other operators and pieced together a system that began to criss-cross the United States. Originated in 1928 as part of the large United Aircraft and Transport conglomerate, the company had acquired, by 1931, National Air Transport, Boeing Air Transport, Varney, and Pacific Air Transport. The quaintly shaped stamped foil label illustrates the route flown by the company and a Boeing 80A tri-motor biplane that carried twelve to eighteen passengers and cost seventy-five thousand dollars per copy. The statement "The Main Street of the Skyways" is noteworthy.

12) This magnificent bold Deco label in brash colors illustrates a Curtiss Robin four-seat aircraft—the same type plane in which Douglas "Wrong Way" Corrigan made his famous New York to Los Angeles flight via Ireland. Curtiss Flying Service began operation in 1924, offering passen-

ger service from Boston to Nantucket and Bar Harbor—popular East Coast resorts. Headquartered in Garden City, New York, the company ceased operations in 1931 because of the Great Depression.

The Continent Below

1) Almost formal in its presentation, this Koninklijke Luchtvaart Maatschappij (K.L.M.) label illustrates an elaborate winged crown with the company's initials riding over a bird-encircled destination of Malmö.

2) Magyar Legiforgalmi (Malert) began operations in 1923 with a day service between Budapest and Vienna. During the 1930s, the airline expanded to Germany, Czechoslovakia, Poland, and Rumania but ceased operations in 1940 due to the war. Their first label features Hungary's national colors and a Fokker tri-motor aircraft.

3) Österreichische Luftverkehrs A.G. (ÖLAG) was founded in 1923 with single-engine Junkers monoplanes for the Vienna-Munich route. By 1939, the airline was absorbed by Deutsche Luft Hansa when Austria came under German domination. The label features the same cold image of

other German labels and illustrates a Junkers transport against a stark geometric background.

4) A.B. Aerotransport was a Swedish airline formed in 1924 to offer the first passenger service between Stockholm and Finland. The route structure was rapidly expanded, with a night mail flight to London starting in 1928. Sweden attempted to maintain neutrality during World War II, and the line flew to Berlin, Moscow, and London, but these routes soon became unworkable. The label uses the device of a plan view of an aircraft in red against a black background

5, 7) Both of these ominous Deutsche Lufthansa labels illustrate lumbering Junkers Ju-52 tri-motor transports dominating maps of Europe and Britain. The Ju-52 was an efficient passenger and cargo aircraft that could be equated to Henry Ford's tri-motor in America but, once the Second World War started, the Nazis soon learned that determined opposition (whether from ground fire or fighter aircraft) would slaughter the slow transports that were used for the invasion of Europe. The red, black, and creme label (5) is particularly ominous since the red silhouette of the Ju-52's wing is crossing Britain—a sign of what was to come.

6) With Germany banned from developing an air force by World War treaties (something the newly emerging Hitler completely ignored), the country turned to creating an "efficient" airline system—after all, if Hitler could make the trains run on time, then why not the airlines? The German aeronautical industry combined its considerable talents into creating a wide variety of remarkably efficient transports. Luft Hansa (the apparent pre-war spelling, although it was sometimes not followed and combined into the singular Lufthansa) developed a wide variety of routes through Europe and Britain (often using secret cameras to photograph military facilities). Luft Hansa created a wide variety of labels, but this is certainly one of the most attractive—and Germanic. A baggage-laden coach with a lady of privilege rears to a halt (as does her faithful dog) to watch a swastika-bedecked Junkers Ju-52 tri-motor drone overhead in a wonderful combination of old and

modern. Hitler imposed an order that all Luft Hansa aircraft carry the swastika in 1936.

8) With almost frightening speed, Luft Hansa expanded its route network during the 1930s to test new aircraft that might serve as bombers as well as transports. This 1936 design illustrates, in a rather cold Teutonic manner, a tri-motor aircraft flying above clouds and mountains—which are attractively picked out in a fifth-color gold.

9) Det Danske Luftfartselskab began operations in 1920 with flying boats and serviced locations in Germany. The airline soon switched to landplanes and began service expansion to London and Vienna. The line was eventually incorporated into SAS. Set against a bright blue background to emphasize its overwater routes, a Fokker tri-motor is seen above the company's prominent logo, which again underlines the overwater flights by incorporating a sea gull and a wave motif.

10) Deutsche-Russische Luftverkehrs Gesellschaft (Deruluft) was an unusual joint attempt by Germany and the Soviet Union to create an airline that serviced both countries. The label illustrates a speeding monoplane heading toward threatening clouds that are parting to reveal a map of Deruluft's route structure. The prominent monuments in Berlin and Moscow are shown to emphasize the dual purpose of the company. In 1933, the German routes were taken over by Luft Hansa, while the Soviet routes were absorbed by Aeroflot.

11–12) Polska (later Polskie) Linje Lotnicze was formed in 1929 by combining several small air-lines to become the national carrier of Poland. These two labels reflect the later name change to LOT, and both achieve a certain artistic ele-gance—the 1932 example illustrates a streamlined single-engine monoplane overflying a very pas-toral village; the 1933 label utilizes a tri-motor transport against a background of greenish, air-brushed clouds as a selection of flags from the countries that LOT serviced rises almost like a monolith. LOT was destroyed by the German inva-

sion of Poland during 1939 but reappeared in 1945 under communist control.

13) After World War II, KLM Royal Dutch Air Lines rapidly began to repair and expand its shattered network. This immensely attractive label gives a feeling of the opti-mistic attitude that existed after the end of the war. The slo-gan "All Over the World" is powerfully brought home with an image of the globe being circled by four-engine Douglas DC-4 airliners.

14) The appropriately named Imperial Airways was formed during 1924 by a merger of several other lines and immediately opened an international service, eventually forging a difficult aerial route all the way to Australia. The Imperial Airways Ltd. label is a masterpiece of Edwardian design, with standing passengers waving at a variety of passing aircraft and ships while an "Old Brit" stoically reads the *Times* with monocle jammed firmly in place. Of interest is the artist's accurate depiction of wicker seats—which were used by the early airlines to reduce weight—and the inaccurate representation of large, open "windows" which, if truly present, would have certainly dis-turbed the "Old Brit's" carefully contoured tonsorial efforts. Using a variety of lumbering biplanes, Imperial Airways

effectively hammered out a modern system of aerial trans-port from Britain to Europe.

15) As newer aircraft became available from British fac-tories, Imperial Airways was able to modernize and offer more comfortable and faster service to a wide variety of destinations. Extending routes through Africa, Asia, and India, Imperial Airways was able to show the flag in a good many corners of the Empire. By 1938, a through ser-vice to Australia was finally established, even though it took an adventurous passenger to complete the journey. In 1940, and with the advent of the war, the company combined with British Airways to form British Overseas Airways Corporation (BOAC). The very simple label illus-trates the "speedbird"—a stylized bird motif that exists today with British Airways—while the label does not forget to remind the traveler to "Also Send Your Freight & Mail by Air."

16–17) Societa Italiana Servizi Aerei (SISA) began oper-ations in 1929 with flying boats from Trieste. The two colorful labels show an early flying boat over a port city, and both carry the destination to which the passenger was traveling. SISA was eventually combined to form the pre-war Italian national airline, Ala Littoria.

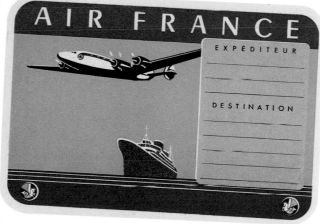

18) Begun in 1926, S.A. Aero Espresso Italiana initially serviced Constantinople with Dornier sea-planes. In 1930, service was expanded to Athens. By 1934, the airline was combined to form the national carrier, Ala Littoria. The label, once again done in poster style, is quite elegant—illustrating a Dornier Wal seaplane over-flying the historic ruins of the cities serviced. An ominous note is added with the depiction of the symbols of Mussolini's growing fascist movement at the bottom of the label.

19) Société Anonyme Belge d'Exploitation de la Navigation Aerienne (Sabena) began operations in 1923 with service to the Netherlands, Germany, and Switzerland. Services expanded and, by 1926, Sabena had forged a route to the Congo to service

Belgian interests in that area. Today, the company is one of the oldest continuously operating airlines. The very attractive poster-style label shows a Fokker tri-motor casting its shadow on the sea. A flight of gulls emphasizes the international aspect of the carrier.

20) Beginning service during 1926 by flying a Genoa-Rome-Naples route, S.A. Navigazione Aerea rapidly expanded to Greece and Egypt. In 1934, the carrier was merged to form the national airline, Ala Littoria. Done in the style of a roundel, the label gives the destination, Genova, while illustrating one of the dozen Dornier Wal (Whale) flying boats operated by the company.

Wings Over The World

1) "The Great Silver Fleet" on the Eastern Air Lines label refers to the fact that the company's planes were basically unpainted. Their natural aluminum skin was buffed to a high gloss, making the aircraft look as if it had been sculpted out of silver.

2) During 1934, Northwest Airways was renamed Northwest Airlines and operated a Chicago-to-Seattle system. The line was to grow and prosper, eventually becoming today's Northwest Orient Airlines, which operates a global schedule. The 1934 label is simplistic but effective, using a roundel design with a pair of wings mounted in the center. The line was awarded a government contract during 1934 to fly mail between Fargo, North Dakota, and Seattle, Washington—a trip of some 1,286 miles.

3) Eagle Airways opened shop during 1953 with a most curious route—it flew from Britain via Munich to Yugoslavia, where sun-starved Brits were treated to inexpensive package holidays at the popular Yugoslavia beachside resorts. The red, yellow, and white label used a rather crude eagle as its main focus.

4) Started by the Frank Martz Coach Co. in Wilkes Barre, Pennsylvania, in 1930, this airline provided service from Wilkes Barre to Newark, New Jersey, using a trio of sin

gle-engine Bellanca Airbuses and a single Ford tri-motor. The airline expanded its route to Buffalo but, by 1933, was bought out by American. The strong orange and black label uses a mallard duck to underline the theme of "Speed-Courtesy-Safety."

5) Formed in 1947 with backing from American investors and Pacific Overseas Airlines of the United States, Pacific Overseas Airlines (Siam) flew from Bangkok to India and Hong Kong. In 1951, the company combined with another airline to form Thai Airways. The extremely curious label shows a strange winged creature in a flying pose (perhaps having something to do with Siamese mythology) and is bordered with the airline's name in both English and Siamese.

6) During 1937, Varney Air Transport was renamed Continental Air Lines and headquartered in Denver, Colorado, eventually increasing its routes and size to become today's trouble-plagued Continental. This 1939

label makes use of a single stylized wing to highlight an American Indian's elaborate headdress. Also, a stylized winged craft is incorporated on the bottom left of the design.

7) Originally beginning operations in 1948 as Robinson Airlines, the company changed its name to Mohawk Airlines in 1952 and its winged label used a strong profile of an American Indian to underline the theme of "The Route of the Air Chiefs." Mohawk merged into Allegheny Airlines in 1971.

8) Created during the early 1930s as Star Air Service, the airline operated a variety of bush flights, along with some scheduled services and charters. In 1944, the company became Alaska Airlines and started operations with DC-3s. The winged label resembles the uniform insignia that would be worn by flight crews. The North Star is transfixed over the top of the globe, making for an attractive image.

9) Yet another of the many small airlines formed after the war, Veterans Air Line made a very direct statement that it was operated by ex-military pilots, and the line flew passenger and cargo service. The label is striking in the bold imagery of a winged V surmounted by a star—the V could also stand for the popular "V for victory" symbol used extensively by the Allies during the war.

10) In 1926, two of Canada's largest cities, Montreal and Toronto, were connected only by railway, since roads between the two major population centers had not been completed. Canadian Airways received government grants to operate an airlink between the cities and this became a popular and efficient form of travel. Canadian Airways expanded its services through the entire eastern seaboard of Canada and, in 1942, combined with several other companies to form Canadian Pacific Airlines. The company used the image of the hard-working yet durable Canadian goose, with wings raised in flight, as the centerpiece of its simple label.

11) Francisco "Pancho" Sarabia was a leading light in the early days of Mexican aviation. As a youth, Pancho

learned to fly in the U.S. courtesy of the postal service. While on a visit to Mexico during the early 1930s, Pancho couldn't help but notice the flurry of activity that the coffee and gum industries were creating in the eastern part of the country. Realizing he could capitalize on what the industries lacked—easy transportation—Pancho created his airline in 1933. Transportes Aereos de Chiapas proved to be tremendously successful, and Sarabia went on to even more aviation breakthroughs for Mexico, including a record-breaking flight from Mexico City to New York. He was later killed during a record attempt after crashing in the Potomac River. The label is quite traditional, with the wings having an almost Aztec appearance.

12) Marquette Air Lines (originally named Midwest Airlines) flew a service from St. Louis to Cincinnati, Toledo and Detroit. The line was sold to TWA in 1941. The attractive foil-stamped label illustrates a winged M with the name of the company prominent in the foreground.

13) Cook Strait Airways was created to operate between New Zealand's North and South Islands and flew this route from 1935 to 1940, when service was suspended because of the war. In 1945, the airline was reformed and eventually became part of New Zealand National Airways. The simple label features a conventional pair of wings with the initials of the airline forming its center.

14) After the devastating effects of World War II, France rapidly rebuilt its national airline with aid from the United States. The warm-toned label features a stylized image of Pegasus and a Lockheed Constellation—the type of aircraft with which Air France was operating transatlantic services.

Cross-Country

1) Thompson Aeronautical Corp. was created in 1927 and won Air Mail Route (CAM) 27 during 1928. This route flew between Chicago and Detroit. Thompson operated a small fleet of the magnificently gothic Loening Air Yachts and began passenger service between Cleveland and Detroit during 1929. Presumably, the majority of oper-

ations occurred on water, even though the craft was an amphibian. In 1931, the company became Transamerican Airlines Corp. and was sold to American Airways in 1933. The label is of a rather stolid Deco design.

2,14) With the help of Pan American management, Boston-Maine Airways began business using Stinson tri-motors operating from Boston's Logan Field to various locations in Maine. The Stinsons were large, lumbering high-wing monoplanes but they were also fairly reliable, and this unusually shaped label makes the most of a simple design, prominently featuring the motto "The Flying Yankee of the Air." By 1937, the airline had become Boston Maine-Central Vermont Airways, servicing Maine, New Hampshire, and Vermont. Using a sleek Lockheed Model 10 Electra in the label, the Yankee connotation was carried through with an image of a Puritan (complete with bible and musket!) astride the fuselage. The motto of "Making a Neighborhood of the Northeast" was soon to come true, and, in 1940, the line became Northeast Airlines.

3) Throughout 1928, Universal Air Lines Systems was in the process of welding a series of small airlines into a cohesive whole. Universal would combine with the first Braniff, Continental, and Central Airlines. Universal, which itself was absorbed by American in 1929, started with five aircraft and a staff of twenty-five, flying from Chicago to Cleveland, eventually creating a coast-to-coast network. The attractive little label extols the virtue of "Travel by Air" and illustrates a Fokker tri-motor that promises "Comfort, Speed, Convenience" while overflying a pastoral city.

4) Braniff was organized in 1928 by Paul and Tom Braniff with backing from two Oklahoma oil companies. Braniff started passenger service (without an airmail contract, a daring move for the time period) using a single-engine Stinson Detroiter. Braniff had entered the market during an aviation boom in a rich area where passenger transport was at a premium. However, Braniff found the operation of exclusive passenger service economically impossible without the supplement of a mail contract to provide a foundation

of revenue. In 1929, as the Depression grew, the airline was sold to Universal. Braniff reorganized during 1930 and survived precariously without a mail contract until 1934, when the government awarded Braniff the Dallas-Chicago mail route. When Tom Braniff died in 1954, his airline's network stretched to Buenos Aires. This attractive silver label features a single-engine all-wood Lockheed Vega with the slogan "World's Fastest Airline." Braniff liked to make a play on words with the logo "The B Line."

5, 13) Central Airlines acquired the route from Pittsburgh to Washington (also servicing Akron, Cleveland, and Detroit) during 1934. The company's label (5) was simple but striking with a central roundel design flanked by bars and a stylized arrow piercing yet another roundel that proclaimed the company was operating Air Mail Route 14. Once again, the importance of having an airmail contract is stressed by the motto "Fly with the Air Mail." Originating as Clifford Ball Airline in 1927, the company was given its new name in 1934. This did not last long, since the company merged with Central Airlines in 1936 and became Pennsylvania-Central Airlines. This company issued a variety of labels, and the one illustrated (13) is a masterpiece of Deco design, featuring a speeding Boeing 247D transport in a silver fifth-color. The name is presented in a very plain Deco type, and the initials are enclosed in a stylized Deco device. In 1951, the company became Capital Airlines.

6–7) New York Airways Inc. was created in 1927 and began flying the profitable New York (via Long Island) to Atlantic City, New Jersey, route in 1930 with Fokker tri-motors. The company soon expanded to Baltimore and Washington but, in 1931, became a subsidiary of Pan American Airways, who further expanded the route in Canada. The labels are interesting because of the strong Art Deco black-and-white design and because the elements of the first were recycled into the second. The rectangular New York Airways label uses a rather straightforward profile of a Fokker bisected by the design, with the two destinations simply placed at the bottom of the label. By the time Pan American had taken over, the same design was used but the tri-motor was given a more "speedy" look to go with the motto "Slash Time—2 Miles a Minute." More destinations are listed, and one might think that "The Sky Route" is the name of the company. Closer examination, however, shows a minute Pan American logo on the fuselage of the tri-motor. The route passed to Eastern in late 1931.

8) New England's Colonial, with William Rockefeller as a major shareholder, began operations with the lucrative New York-to-Boston mail route in 1923. Passenger service started in 1927 under the leadership of one of aviation's founding fathers, Juan Trippe (who went on to create TWA, with some help from Charles Lindbergh). Colonial Airways was acquired in 1930 by Avco

and, along with several other small airlines, became American Airways.

9) Quebec Airways Limited was originally formed during 1935 by a successful steamship line to enhance the company's service in the St. Lawrence River area. The small de Havilland biplanes could be fitted with floats or skis, depending on the season. The label is foil-stamped (a not-uncommon feature of Canadian labels) and dominated by a fleur-de-lis (flower of the lily), which is also the symbol of the French royal family and ties in the strong French-Quebec tradition. During 1935, Trans Canada Airlines took over the company's operations.

10) And to all a good night. Certainly one of the most special of all labels is this small example issued by Interstate Airlines to passengers flying on Christmas, 1929. A colorful green-and-red Christmas wreath extends greetings for the special flight. Once again, airmail was never far away from the early operators' minds and "C.A.M. 30" is prominently placed on the label.

11) During 1934, Pacific Seaboard Airlines changed its name to Chicago and Southern Air Lines when the company acquired a Chicago-to-New Orleans airmail and passenger route. By 1937, the company was operating Lockheed 10s (with an ampersand between Chicago-Southern). This handsome foil-stamped label shows the aircraft, along with the motto "The Valley Level Route" and a winged "Fly C&S" logo with stars and a sunburst.

12) Based at Ottawa, Ontario, Laurentian Air Services Ltd. (named for one of the earth's oldest and most treacherous mountain ranges) operated into the Laurentians on charter operations. The foil-stamped dark green and gold label features a single-engine Waco cabin biplane on floats flying over mountainous terrain that is studded with lakes.

15) Wings Limited set up operations in Winnipeg, Manitoba, during 1935 and

operated a fleet of small bush aircraft to service the surrounding area. In 1939, the company joined with several other airlines to form United Aircraft Services. Another foil-stamped label, the Wings Limited image is particularly strong since it illustrates a small float plane coming directly at the viewer, its whirling propeller disc containing the company's name. Surrounding the outer portion of the label is the comforting motto "Expert Air Transportation."

16) MacKenzie Air Service was originally established in 1931 and began flying routes in the Northwest Territories, going as far as the Arctic coastline. In 1939, the airline combined with several other small operators to become United Aircraft Services, which, in turn, eventually became Canadian Pacific Airways. The label shows a small twin-engine bush aircraft on skis flying over the top of the world and set against the aurora borealis.

17) The Ludington Line (also known by the more complex The New York, Philadelphia, and Washington Airway Corporation) was created by a group of Philadelphia financiers headed by C.T. Ludington. The airline unfurled its wings during September 1930, with a route that linked New York, Philadelphia, Baltimore, and Washington. The company used Lockheed Vegas and Stinson tri-motors on their regular service, which boasted the coveted frequency of "Every Hour on the Hour" (from 8 AM to 5 PM). The public quickly accepted the Ludington Line since it was the first airline to offer railway-type scheduling. Some fifteen thousand passengers were carried during the first three months (during the Depression!), and the company was sold at a profit to Eastern Air Transport during 1931. One of the strongest Art Deco labels in the book, the design makes effective uses of geometric patterns and of the colors black, white, and orange. The Stinson tri-motor forms the centerpiece.

18) Interstate Airlines was created in 1928 to fly mail and passengers between Chicago and Atlanta. The short-lived company was gobbled up by American Airways in 1929. The bold design uses the letter I as the main theme of its design, along with a fleeting Mercury and a primitive two-seat open-cockpit biplane. Once again, the popular Deco-

On foreign soil you're greeted by a friendly Passenger-Service-Representative who speaks English, makes you feel at home abroad.

PAN AMERICAN WORLD AIRWAYS
The System of the Flying Clippers

era colors of black, orange, and white are combined.

19-20) TWA declared bankruptcy in 1992, and its long and successful history ground to a halt in the legal system. TWA was founded by the merger of Transcontinental Air Transport and Western Air Express (the Los Angeles-to-Kansas City route) during 1930. From this point on, TWA became a dominating force in the airline business (the name was later modified to Trans World Airlines to denote an international status). The first label, issued in 1930, depicts a Transcontinental & Western Air, Inc. Ford tri-motor suspended above a route map that proclaims "Shortest Route Coast-to-Coast." The second TWA label, and a favorite of the authors, is of interest on a couple of counts. First, it employs an extremely attractive oval shape with a "stewardess" executed by George Petty, an artist extremely well-known during the 1940s for his "Petty Girls" –a series of well-rounded females presented in popular men's magazines of the period such as *Esquire*. In the background is a Boeing 307 Stratoliner, five of which were purchased by TWA as the first four-engine pressurized air liner that would allow passengers to fly in relative comfort "above the weather." Secondly, the label employs the wartime logo "Let's Go! U.S.A. Keep 'Em Flying." During 1942, the TWA 307s were drafted by the Army Air Force and became C-75 military transports.

South of the Border

1) Founded in 1928 by American entrepreneur Slim Faucett, Compania de Aviacion Faucett began domestic services from Lima with float planes. In the first year of business, Faucett carried 250 passengers over thirty thousand miles and never looked back–increasing the number of aircraft and routes. Faucett even went as far as having specialized aircraft built specifically for some of his more remote routes.

2-6, 9) CIA. Mexicana de Aviacion started charter operations throughout Mexico with a variety of small aircraft during 1924, servicing Merida, Tampico, Vera Cruz, and eastern Mexico. Scheduled services started in 1928,

and in 1929 Pan American Airways purchased the airline and increased its route to locations in the States and Guatemala. The first three labels, in a matching square format, are interesting because they use the traditional bright colors and depict various aspects of Mexican culture. All three labels use stylized tri-motor aircraft seen over diverse locations, including: a Spanish mission highlighted with a mountain backdrop and framed with cactus (2); a traditional native goods display, again with a mountain backdrop (3); and a farming scene with a canal barge (4). The fact that the airline was now owned by Pan American is kept to a fairly simple statement on the bottom of the labels. By 1930, a larger rectangular label of quite spectacular imagery was created to show passengers boarding a tri-motor aircraft and a globe rising out of billowing clouds (9). The globe shows the Mexicana system and how it was now linked to the United States and other locales in Latin America. Also, the Pan American statement has grown in size and includes the company's logo of a winged globe.

7) When Juan Trippe organized Pan American Airways in 1927, the company's first flights, which went from Key West to the popular casinos in Havana, used this label. In the foreground, two smartly Deco-garbed passengers deplane while a swarthy skycap handles a manful load of bright orange luggage, the round one bedecked with labels. A huge and rather menacing silhouette of an aircraft dominated the background. For added effect, Pan

American is reversed out of the black of the wing. It is interesting to note that the passengers and skycap are exactly the same as on the label featured on the acknowledgments page, but everything else has been changed.

8) As Pan American progressed on its route expansion, the company needed bigger aircraft and purchased the Sikorsky S-42 four-engine flying boat. Pan Am used this aircraft to establish its Pacific route and to service its established South American flights. Again, in a case of wastenot, want-not, the artist used the same art as the CIA. Mexicana de Aviacion label in this chapter but substituted the flying boat for the tri-motor and added "America's International Air Transport System" to the bottom of the label.

10) Founded in 1933 by Ernesto Samper Mendoza, Servicio Aereo Columbiano (SACO) flew only two routes, but they were both extremely popular since they linked Columbia's largest cities. Sadly, Samper was killed in 1934 when the tri-motor he was piloting hit another tri-motor in the air, killing seventeen people–an enormous aerial accident for the time period. SACO merged with SCADTA in 1941 to become Avianca. The simple but attractive label effectively used blues and red while the "O" of the company's name also forms the tire of the aircraft!

11) When the Peron government in Argentina ousted both

American and European interests in 1946, Flota Aerea Mercante Argentina (FAMA) was the first established Argentine international airline and flew Douglas DC-4s to Europe, Africa, and the United States. During 1949, FAMA merged with other Argentine airlines to form Aerolineas Argentinas. The complex label uses Argentina's national colors of blue and white in a series of concentric circles to form a globe over which a four-engine aircraft is flying.

12) Bolivia's first airline was founded by three young German businessmen with a single Junkers aircraft. The territory Lloyd Aereo Boliviano serviced was brutal terrain that included the towering Andes. A typical one-hundred-mile ground journey could easily take three days. By the late 1930s, LAB was a large concern (with hidden Nazi connections) serving most of South and Central America. In 1941, with the Second World War raging in Europe, the United States forced nationalization of the airline and "fired" all the German employees (paying off local authorities in a handsome manner) by using the rather flimsy excuse that LAB was not giving its passengers reliable service. The airline still operates today under its original name. Many of the fired Germans formed all-German communities with a distinctly rightist political view within the country that are still active today. Effectively using the national colors, the label illustrates a Junkers Ju-52 trimotor soaring above an oxen-powered wagon.

13) Operating domestic flights since 1929, Compania Nacional Cubana de Aviacion Curtiss was formed by Cuban businessmen, with a major shareholder being American aircraft builder Curtiss. In 1932, the line was purchased by Pan Am, and the Curtiss name was dropped from the logo. The rather primitive label shows a Ford trimotor, passengers, and a skycap with a large consignment of baggage—all with location tags for Cuban cities; the golf clubs are going to Havana.

14) Chicago and Southern Air Lines opened a Havana route to service the rapidly growing tourist and casino industry of dictator Juan Batista's island nation. C&S was taken over by Delta in 1953, and the service came to a

violent halt when Fidel Castro and his gang took over the country. The label is printed in rather unattractive 1950s shades of green and yellow and offers a "foreign" touch with "Saludos Amigos" in the left corner.

15) Again with the help of American aid, The Netherlands quickly rebuilt their national carrier, KLM, after the devastating effects of World War II. Operating a variety of American equipment, KLM reopened its international routes and this image of a gaucho with palm trees in the background and a speeding Douglas transport overhead highlighted KLM's flights to South America.

They All Flew Goonies

1) During 1934, American Airways was renamed American Airlines after some government air mail contracts were cancelled and the company's route structure was revised. The label issued in 1934 by the company matched its Curtiss Condor biplanes that were painted a deep blue with orange and white trim. An eagle with wings outstretched stands astride a globe—indicative of the world-wide routes now flown by American. The Label was retained for the introduction of the DC-3 and the design can plainly be seen on the fuselage of the accompaning photograph.

2) Formed in 1936 by the merger of several smaller airlines, Australian National Airways introduced DC-3s to the lucrative Sydney-Melbourne-Brisbane-Adelaide routes. The airline was a successful operation and was bought out by Ansett Airways. The rather traditional label depicts a DC-3 in flight and has room for the passenger's name and destination.

3) One of the many aerial "taxi" services that sprang up in Mexico after the end of World War II, Taxis Aereos Nacionales SA (TANSA) had at least one DC-3, but very little else is known about the short-lived operator. However, TANSA did issue one of the most distinctive DC-

3 labels, displaying a die-cut DC-3 in full flight with the company name and Mexican registration under the wing.

4) Starting service directly after World War II with a very impressive fleet of seventeen DC-3s, Zonas Oeste Y Norte de Aerolineas Argentina (ZONDA) was based out of Buenos Aires and began flying throughout Argentina, Chile, and Bolivia. In 1947, the company combined with several other airlines to form the national carrier Aerolineas Argentina. The label is of interest because it conforms exactly with the side profile of a DC-3 and is finished in full ZONDA colors, with Argentina's national colors being applied to the rudder.

5-6) Polskie Linie Lotnicze (LOT, Polish Air Lines) began operations in 1929 after several smaller airlines merged their resources. Operating a variety of German and Amer-American aircraft, LOT rapidly spread its network through Europe and introduced the new Douglas DC-3 into service as soon as the aircraft became available. LOT was virtually destroyed by the German invasion of Poland in 1939 and began service again in 1945 under Soviet control. These two labels feature a stylized DC-3 and the airline's name in Polish and English. They were issued in a variety of colors.

7) Originally formed in 1919 by displaced Germans, Sociedad Colombo Alemana de Transportes Aereos (SCADTA) was the first South American Airline to actually offer scheduled and consistent passenger service. A well-run and well-funded (typically Teutonic) operation started to fan out services over South America with its fleet of Junkers and Dorniers. Another side duty was to carefully map all overflown areas and pass the information back to the growing new German military that had ideas about a South American takeover. To counter this threat, Pan American secretly purchased much of the airline's stock, and—as anti-German fervor picked up in the late1930s—all German employees were replaced by Americans and Columbians. Regular operations with DC-3s began with the replacement of the Germans. The swept-wing image of the Gooney Bird lurks behind the company name. In 1941, the airline became Avianca.

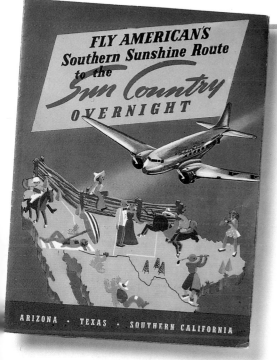

FLY AMERICAN'S
Southern Sunshine Route
to the
Sun Country
OVERNIGHT

ARIZONA · TEXAS · SOUTHERN CALIFORNIA

10) A case of waste-not, want not—the designer of this Pennsylvania Central Airlines foil-stamped label used the basic elements of an earlier label (see Chapter 4, "Cross-Country"), dropping the Boeing 247D airliner and substituting the newer Douglas DC-3, retaining the Deco flavor of the earlier label, and changing the colors to an attractive silver, brown, and French blue. The company profitably operated DC-3s on their routes until the 1950s, when they were replaced by newer equipment.

11) This bright label for TWA helped introduce the Douglas DC-3 to passengers by presenting the aircraft as a powerful image with the slogan "TWA First," indicating that the airline was the first to use the transport that would ultimately change the world. Also, "The Lindbergh Line" is proudly displayed at the bottom of the label, indicating the airline's advantageous link with the famous aviator, Charles Lindbergh. As the 1930s progressed and the rise of Nazi Germany continued, however, Lindbergh's pro-Nazi views became less popular with the American public, and the slogan was quietly dropped.

12) Regular air service over the vast Indian subcontinent started in earnest during 1932 when the enterprising Tata brothers formed Tata Sons—a small airline operating three-passenger de Havilland Puss Moth biplanes. The Tatas acted as pilots, mechanics, and bookkeepers; the Puss Moths flew from Madras (east coast) some 1,200 miles across the continent to Karachi (west coast). The brothers struggled through World War II and in 1946 Tata went public and Air India was formed. The label honors the contribution of the Tatas and introduces the new name to the traveling public as a traditional Indian maid gazes aloft at the distinctive shape of a passing DC-3.

Way Out West

1–2) Western Air Express was established in Los Angeles in 1925 and immediately began forging a strong route system. During its operation, the company had a wide variety of passenger labels and after absorbing National Parks Airways in 1935, issued a label that identified the airline

as the "National Parks Route." The labels always had a strong western/American Indian symbolism, and the Western Air Express label is particularly striking in its use of a strong Indian profile with a headdress stylized into wings. When the company was renamed Western Airlines in 1941, they used a series of baggage labels in the shape of an arrowhead that culminated in a twenty-fifth anniversary edition.

3) Walter Varney established his Varney Air Services during 1934 in California. Varney liked the idea of using aircraft with the highest speeds possible and purchased record-setting Lockheed Vegas. The all-wood Vegas were the fastest thing in the sky, but they had only one engine and a small passenger cabin that seated four. Varney Air Transport was started during 1934 in Colorado, but both operations were renamed Varney Speed Lines (some aircraft were painted with "Varney Speed Lanes") soon after. By this time, the fleet comprised speedy Lockheed Orions, which, while still all-wood, featured retractable landing gear and a larger cabin, enabling Varney to bill his company as the "Fastest Airline in the World." The company was renamed Continental Air Lines in 1937.

4) The small Wyoming Air Service was organized in 1930 and flew Air Mail Route 13 between Denver and Billings. The airline soon began hauling passengers along with the mail to pick up some additional revenue. The label is quantified in a rather simplistic Deco roundel but is saved from the mundane by superimposing a wonderful silhouette of a cowboy on a rearing horse against a splendid Deco sunburst with a monoplane crossing the clear sky. The company was eventually purchased by Inland Air Lines.

5) Inland Air Lines purchased Wyoming Air Services and operated Air Mail Route 28 from Denver to Great Falls, and Air Mail Route 35 from Cheyenne to Huron. The rather fanciful image incorporates a used Boeing 247 transport (ex-United) flying over a snowcapped peak while a cowboy rears high on his horse, offering a salute to the new form of transportation. Inland became a subsidiary of Western Air Lines by 1945 and was completely absorbed by that company in 1952.

8) Although the airlines of eastern European countries were put under communist control after World War II, they usually continued operating with their pre-war names intact. This label for Czechoslovak Airlines effectively illustrates the slogan "Link the Continents" by intertwining the airline's initials—which could also be viewed as an encumbering chain added by the communist controllers.

9) Det Norske Luftfartselskap (Norwegian Air Lines) traced its ancestry back to 1927, when the company began service to Denmark and Germany. During the early 1930s, several steamship owners, including Fred Olsen, invested in the airline. Services to Copenhagen and Amsterdam were added but World War II stopped operations. After the war, the company restarted business with surplus DC-3s and began rapidly building its routes. By 1948, Norwegian Air Lines was combined with several other operators to become SAS. The label, finished in the Norwegian national colors, shows the swept-wing form of a DC-3 soaring over a fjord.

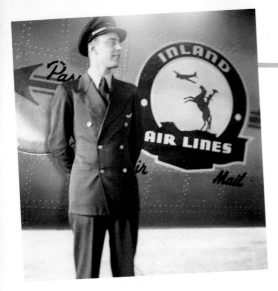

6) Trans-Texas Airways began operations in 1947 after consolidating several other services. Using Douglas DC-3s, the company's service was very popular since it visited many smaller Texas cities on a frequent schedule. The label, in the form of a more contemporary decal, uses a "Dale Evans" image, the evocative Texas flag, and the statement "Route of the STARLINERS." The airline was renamed Texas International Airlines in 1968.

7) Starting operations in 1930, Gilpin operated a charter and scenic flight service between Los Angeles, Agua Caliente, San Diego, and Long Beach. Carrying more than than twenty-five thousand passengers in just one year of operation, the airline ceased business after Gilpin was kil-killed in an aircraft crash. The airline operated a small fleet of the limited-production Bach tri-motor, built in Van Nuys, California. The planes were painted an overall gloss white.

8) Wilmington-Catalina Airline, Ltd., was founded by chewing-gum magnate Philip Wrigley to service Catalina Island, which the family owned, off the coast of Southern California. Originally operating with lumbering Loening Air Yachts, the company progressed to the Douglas Dolphin, built in nearby Santa Monica during 1931. This attractive foil-stamped label illustrates a Dolphin coming head-on to the viewer; the island looms in the background. The planes would land in Avalon Bay and transfer customers directly to the Art Deco casino. Currently, the Wrigley mansion has been converted to a deluxe hotel.

Unfortunately, flying boat service to the vacation island stopped in the mid-1980s.

9) Century Pacific Lines (a name somewhat evocative of the Deco trains that crossed the United States during the same period) was established in 1931 by automotive manufacturer Everett Cord (who, as a clever capitalist, used his Cord automobiles as limos to pick up airline passengers). Century Pacific was able to compete with the railways ("It Cost No More to FLY") to similar destinations. Within six months of inception, Cord's brainchild flew more than fifty-five thousand passengers. A thundering tri-motor heads toward the viewer while the inscription "Passenger Safety First" looms large above the image. Just a year later, Cord sold his line (which started with service from San Francisco to San Diego and expanded to other points in California and Arizona) to American at a profit and went back to his stylized autos.

10) Big and brash, the label for Standard Air Lines underlines the boldness of the developing American west. Printed in brilliant orange and deep purple (Arizona state colors), the label depicts a Deco-stylized Fokker tri-motor taking on passengers for a flight to the cities it serviced: Los Angeles, Phoenix, Tucson, Douglas, and El Paso. The line was formed during 1926 to visit the above cities (with an optional stop halfway across the desert, where a ladies' rest room awaited!). During 1930, Western Air Express purchased Aero Corporation of California (owners of Standard) as part of the aggressive build-up of Western's route structure. One of the rarest and most valuable of airline baggage labels to collectors.

11) Established to serve California's developing San Joaquin Valley (now the world's largest producer of agricultural produce), Cardiff and Peacock Airlines Ltd. (the "Limited" in the title sounds vaguely British, as do the owners' names) was a brave attempt to establish regular air service from Fresno to San Francisco and from Bakersfield to Los Angeles. The label uses a stylized valley area bordered by the Sierra Nevada and the ocean. The aircraft appears to be either a Travel Air or Bellanca monoplane. Depression business was just not enough to support the

fledgling airline, however good its intentions, and it floundered after a year in business.

12) National Parks Airways began business in 1928, operating from Salt Lake City to Idaho and Montana. The airline gave obviously spectacular views of western scenery to passengers from their precarious perch in a primitive single-engine monoplane flying over some of America's more inhospitable terrain. The line also provided sightseeing tours of Yellowstone and Grand Teton National Parks for a munificent $7.50 per person. The label incorporates a more spectacular image of mountains, sky, an American Indian, and a throbbing monoplane boring its way through a clear sky. Founder Alfred Franks sold the line to Western Air Express in August 1937 at a profit.

Adventures on the Wing

1) Pan American pioneered the Pacific and established bases on remote islands to build an effective Pacific service with the magnificent Boeing 314 flying boat (and earlier Martin Clippers). A regular, and expensive, service was provided with flights leaving San Francisco Bay each week and heading west. The service came to an abrupt halt with the Japanese attack on Pearl Harbor, but several heroic flights were undertaken by Pan Am Clippers to supply beleaguered bases and to rescue American personnel. The label illustrates the Philippines, one of the locations serviced by the Pan Am Clippers. The Boeing 314 would land in Manila Bay and taxi directly to a special ramp at the luxurious Manila Hotel, where passengers would deplane and walk across the attractively landscaped grounds to their rooms or the bar.

2) Philippine Aerial Taxi Co. (an evocative name considering the location) was formed during 1931 to give aerial service to the nation's multitude of islands, although the label specifically refers to Manila-Baguio service. The label illustrates a very picturesque setting as a Filipino lass views what appears to be a single-engine Bellanca monoplane droning overhead. In 1936, the company started scheduled services as Philippine Air Transport Co.

3) This short-lived airline operated from Siam from 1948 to 1952, servicing surrounding Southeast Asia. During its brief existence, the airline produced one of the more curious labels in this book—a cityscape set against a mountain, an oriental junk on the ocean, a dancing woman in traditional Siamese dress, and, oddly, a topless dancing girl being accompanied by a guitar player.

4) Because Australia and New Zealand are islands, the flying boat played an important role in developing those countries' airlines. Tasman Empire Airways Ltd. (TEAL) was formed in 1940 and used Shorts Brothers flying boats to operate between Auckland and Sydney. The airline was jointly owned by New Zealand, Australia, and Great Britain. In 1950, the airline expanded its route as far as Tahiti; sadly, by 1960 the company switched to more modern airliners. The label shows, once again, a powerful head-on image of the flying boat superimposed over a white sun and red and silver background.

5) Few labels could be more powerful than this Qantas issue that shows a thundering Shorts Brothers flying boat heading directly at the viewer. The flying boat service offered by Qantas went from Sydney to London in a rather stately style, but it still cut weeks off the ocean liner journey.

6) Dai Nippon Koku Kaisya (Japan Airways Co.) came about as a reorganization of other airline services during 1938. Operating throughout Japan, a service to Bangkok was started in 1940. Owning a fleet of DC-3s, Lockheed 14s, and Mitsubishi Mu-20s, the airline became the transport service of the Japanese Armed Forces after the start of the war. After VJ Day in 1945, the airline was dissolved on orders of the occupation force; its remaining aircraft were destroyed. The label depicts a Douglas and Lockheed transport against a stylized sky background in blues and red.

7) Attractively presented in yellow, blue, and red, the label for Manchurian Air Transport is an interesting example from that country's only airline. Established by the Manchurian government in 1932 after that nation was occupied by Japan, the airline flew routes through Manchuria with connections to Japan and China. The airline lasted until the country was taken over by Russian troops during the closing stages of World War Two.

8) Formed in 1931 and flying already elderly all-wood Fokker tri-motors, New England Airways flew between Brisbane and Linsmore, eventually extending to Sydney. The company was short-lived, being taken over by Airlines of Australia in 1936. The rather pastoral label shows a company tri-motor (detailed down to the registration, VH-UNJ) taking on a load of passengers and cargo.

9) Cathay Pacific Airways was originated in the Crown Colony during 1946 by British business interests to supply services to a good portion of Asia. Beginning with Douglas DC-4s, the airline went on to operate a wide variety of equipment, and its modern jets now operate to all major Asian destinations. The label is oriental in design and color, showing a DC-4 flying over a very traditional Chinese city and junk. Colors are muted, and the airline's carried in both English and Chinese.

10) Civil Air Transport was established by General Claire Chennault (who had led the American Volunteer Group—the famous "Flying Tigers"—against the Japanese in 1941) as a transport service to help fly the retreating Nationalist Chinese army to Formosa as mainland China was overrun by communist forces. The label shows a head-on view of a Douglas DC-4 transport; lines extend from its wings to the many locations (printed in English and Chinese) that CAT serviced. The slogan "The Orient's Own" exemplified the fact that the airline's service was all related to the Orient. The airline lasted until the jet age and operated a beautifully painted and decorated Convair 990 "Mandarin Jet" on its most important service. The crash of this jet, however, led to the collapse of the airline and the takeover of its routes by China Airlines.

11) Guinea Airways Ltd. was originally founded in 1927 with the specific purpose of servicing the rich gold fields recently discovered in the wilds of remote New Guinea. Pilots, passengers, and aircraft had to be of a hardy nature since some of the locals over which they winged had little problem with a heaven-delivered gift of tasty Anglos. Operating a wide variety of early aircraft, the line had a

Made in U.S.A.
LAD-A14-100M-45

PAN AMERICAN WORLD AIRWAYS

surprisingly good safety record, considering the extremely primitive nature of the country. During 1937, Guinea Airways began a passenger flight from Darwin to Adelaide and Sydney. Routes continued to grow until the operation was taken over by Ansett during 1958 and renamed Airlines of South Australia. Although rather somber in design, this label is of definite Deco influence (with a slight tropical flavor by the style of the lettering); the stylized tri-motor aircraft and the slogan "Dependable Transport Always" are noteworthy.

12) Western Australian Airways Ltd. was one of the pioneering airlines, originally opening shop during 1921 to provide a flight from Derby to a railhead north of Perth. Using converted World War I combat aircraft, the route grew to include Perth itself by 1924 and Adelaide by 1929. The line was taken over by Adelaide Airways in 1936. The label is a strong Deco image using the moody colors of light green, black, deep blue, and orange to illustrate a tri-motor aircraft caught in the beam of a search light (a popular conceit of Deco designers). The slogan "Quicker by Days" was obviously the truth, but it is interesting to note that the airline's name appears only in very small type on the side of the aircraft's fuselage.

13) This extremely unusual label reflects a turbulent time in history and an air service that was created to cope with a major problem. When Hitler's death camps were overrun in 1944, the remains of Europe's Jewish population became a problem. The majority of the survivors had little desire to remain in Germany or Central Europe, and many opted for a new homeland in the emerging state of Israel. Others hoped that far-away South Africa would remove them from their nightmares, and Universal was created to take passengers between Israel and Johannesburg, with many stops in between. The label is curious since it shows a "road sign" between South Africa and Israel topped by a globe and a flag with the Star of David. The main colors are blue and white, with the continent of Africa in yellow and red. The many stops made by the airline are indicated on the label. Universal was taken over by El Al during 1950.

14) Any flight on a Bulgarian airline would have to be somewhat of an adventure! TABSO (Bulgarian-Soviet Joint Stock Company for Civil Aviation) was formed in 1949 as a government-operated interior Bulgarian airline. Bulgaria purchased the Soviet Union's interest in 1954, and the company became a national airline—eventually renamed (in 1968) Balkan Bulgarian Airlines. As with any communist-controlled airline of the period, the company offered irregular service with disreputable aircraft, and an all-smoking cabin was mandatory. With the collapse of the Soviet Union and its allies, it is not known what, if any, future is in store for the company. As for the label, it is not as drab as most communist designs of the period and offers an attractive stylized bird over a gold ring topped with a red star.

15) This very odd Air-India label illustrates a topless maiden (minus nipples, presumably a concession to Indian good taste) fiddling with a wide variety of jewelry. Certainly one of the stranger labels in the book.

16) This well-proportioned lass would not be out of place with the Petty girl illustrated in Chapter 4, "Cross Country." A pert stewardess salutes arriving passengers in this attractive ANA (Australian National Airways) label.

Labels not included in the chapters

FRONT COVER: Societa Aerea Mediterranea (SAM) was formed in 1926 and started flying-over the Adriatic from Trieste with splendid Art Deco Savoia Marchetti flying boats. By 1929, service extended to Rome, Sicily, and North Africa. SAM was eventually absorbed into Alla Littoria, Italy's pre-war national carrier. The poster-style label illustrates a stylized Savoia Marchetti over a port city; the passenger's destination, Roma, is listed at the bottom. A number of variations of this label exist, showing the differing locations that the airline serviced.

TITLE PAGE:

UAT, FRANCE, CIRCA 1952
Perhaps the ultimate baggage label? France's progressive UAT issued this label for passengers enjoying their tours to many of the vacation spots that the airline serviced.

ACKNOWLEDGMENTS SPREAD:

PAN AMERICAN AIRWAYS, UNITED STATES, CIRCA 1929
When Juan Trippe organized Pan American Airways in 1927, the company's first flights, which went from Key West to the popular casinos in Havana, used this label. In the foreground, two smartly Deco-garbed passengers deplane while a swarthy skycap handles a manful load of bright orange luggage, the round one bedecked with labels. A huge and rather menacing silhouette of an aircraft dominated the background.

THIS CHAPTER:

AIR FRANCE, FRANCE, CIRCA 1954 (PAGE 111)
This bold label from Air France is of considerable interest since it combines two modes of luxury travel— the four-engine Lockheed Constellation overflying a stately ocean liner.

TWA, UNITED STATES, CIRCA 1949 (THIS PAGE)
Certainly one of the grandest labels in this book (the original measures over ten inches), TWA made a bold move to advertise its new Lockheed Constellation service with this magnificent silver foil label that highlights the classic design of the triple-tail Constellation.